LET YOUR CREATIVITY WORK FOR YOU

How to Turn Artwork into Opportunity

Heather Allen, MBA

LIBRARY OF CONGRESS NUMBER: 2014952045

ISBN: 978-1-940984-62-9
Author Photo by Gordon Munro
Cover Design by Maurizio Marotta
Interior Design by Cyn Macgregor | www.cynergiestudio.com
Edited by Tyler Tichelaar | www.MarquetteFiction.com

AVIVA
PUBLISHING
New York

Aviva Publishing
Lake Placid, NY 12946
www.avivapubs.com

Printed in the United States of America

PRAISE

"Heather Allen presents the theme of creative entrepreneurship for artists in a very approachable and encouraging way that moves individuals to reach beyond their preconceived potential to make their magic happen. This is a valuable book for creative people as well as creative organizations."

<div align="right">—M.J. Hall, Author of Designing WorkLearn Networks</div>

"As an artist in business myself, I consider Heather Allen's book to be a treasure trove of resources to help any artist begin, grow, and sustain his or her business. I particularly appreciate the interviews with successful art professionals that made the book an enjoyable read as well as informative."

<div align="right">—Chris Maynard, Author of Feathers, Form and Function</div>

"If you want to live your creative dreams and realize your artistic visions, then start here! This book is the premier launching pad for artists who want to inspire others, share their passion, and earn more for their creative work."

<div align="right">—Patrick Snow, International Best-Selling Author of Creating Your Own Destiny™and The Affluent Entrepreneur</div>

"Dear Artists: It's time to have the art business you've always dreamed of! Use Heather Allen's book as your guide and implement the strategies she teaches to take your creative enterprise to the next level."

—Luis Fuentes, Author of *Life Lessons from The Lantern*

"*Let Your Creativity Work for You* will ignite your artistic mind and enrich your life. Don't settle. Succeed!"

—Jennifer Lee Tracy, Author of *Sincerely, The Mentor: A Journey of Perception*

"In the world of marketing, it's critical for any small business to stand out if it wants to build and maintain a following of loyal customers. Artists are no exception. In *Let Your Creativity Work for You*, Heather Allen shows enterprising artists how to stand out authentically, make a lasting impression through their artwork, and develop a successful business doing what they love most—art!"

—Debra A. Jason, Author of *Millionaire Marketing on a Shoestring Budget*™

"Let Heather take the boredom out of your business. Let her add life, vibrancy, and creativity to your craft."

—Michael Fulmore, Author of *Unleashing Your Ambition*

"*Let Your Creativity Work for You* is an amazing tool for artists in business. You gain the insight of solid business principles joined with real life case studies to create a platform for unbridled success. This book is a must read for creative people who want to create a business or elevate an existing one."

—Dr. Eric J. Scroggins, Author of *Overcoming Your Vision Blockers*

"The technological shifts are creating opportunities for economy, enhancement, or obsolescence within the blurred lines. This guide for up and comers will be indispensable."

—Solomon Burnette, Poet and Rapper

"*Let Your Creativity Work For You* is an eye-opening resource for any artist or creative person who wants to see his or her business thrive. Heather Allen is the reader's personal coach and makes all of her suggestions very doable. This is a must-read for all creative entrepreneurs."

—Sheila Paxton, Author of *Getting Past Jaded*, CEO, Fit4love

"As a career transition expert, I find *Let Your Creativity Work for You* to be a good segue for anyone venturing out on their own creative endeavors. This is truly a start-up, or 'freshen up' resource for those with a desire to turn their artistic passions into profitable businesses, or take things to new heights.

Heather Allen's lists of resources is very helpful, but I think the most helpful component of the book is that it is sequential. Each chapter is a step in building one's creative business. So, read the book cover to cover, but be sure to do the exercises!"

—James Lehman, Author of *Maneuvering Your Career*

In loving memory of Dr. Lynn Jones Ennis

CONTENTS

INTRODUCTION xv

—PART 1—PREPARATION

1. START WITH THE END AND WORK BACKWARDS 1
2. LEVERAGING YOUR STRENGTHS BY KNOWING YOUR STORY 15
3. ORGANIZING YOUR BUSINESS FOUNDATION FOR SUCCESS 33
4. CREATING PREDICTABILITY IN A CREATIVE BUSINESS 61
5. DEVELOPING ROUTINE AS A CREATIVE SOLOPRENEUR 89
6. POSITIONING YOURSELF IN THE MARKETPLACE AND CREATING LONG-TERM VALUE 113
7. IDENTIFYING YOUR AUDIENCE AND UNDERSTANDING ITS DESIRES 129

—PART 2—OPPORTUNITY

8. CRAFTING A BRAND YOU BELIEVE IN 151
9. ENGAGING YOUR AUDIENCE ONLINE 169
10. USING THE INTERNET TO INCREASE SALES AND VISIBILITY 195
11. CULTIVATING COMMUNITY AND THOUGHT LEADERSHIP 211
12. DOCUMENTING YOUR SUCCESS 219

A FINAL NOTE 223

REFERENCE NOTES 225

ABOUT THE AUTHOR 229

ACKNOWLEDGMENTS

This book was made possible by the incredible people in my life:

First and foremost, my gratitude goes to my whole-brain parents who nurtured my spirit and shared the magic of the arts with me from an early age. To my loving and adoring husband, Phillip, who gave me the endless support and encouragement I needed to keep writing.

To my VIPPPs (very important people in the publishing process), including letterpress artist Brian Allen, novelist Jessica Yinka Thomas, playwright Rudy Wallace, my best friend and graduate of art studies, Diana Chase, and to inspirational writer, Vince Rozier, Jr. Thank you also to my fellow authors with The Snow Group for your support. A big thank you goes to my editor, Tyler Tichelaar, who made each draft better than the last. And to my detail-oriented layout designer, Cyn Macgregor, who brought the pages to life.

And most importantly, to the artists I have the absolute privilege of working with and learning from every day. Thank you for welcoming me into your lives and careers. You give my work meaning and purpose.

INTRODUCTION

When the National Endowment for the Arts released its "Artists in the Workforce" research report in 2008, it revealed that among all professional vocations, artists are 3.5 times more likely to work for themselves. The report, published just as the Great Recession began to take hold, argues that artists make up a significant part of the workforce and economy. It also exposes the fact that while artists are more likely to be self-employed than other working professionals, few receive the training and development needed to run a small business successfully.

With less faith and pre-recession predictability in what used to work, new markets have opened along with new avenues for connection and transaction. Now, a world of bloggers, DIYers (Do-It-Yourselfers), crafters, Jacks and Janes of all trades, and multi-passionate people who found their calling to let their creativity work for them, are connecting, selling, and earning in the fields they are most passionate about.

Today, the creative entrepreneur can succeed at any age. There is no time in the history of mankind like today for the independent artist and creative entrepreneur to thrive.

Though the times have changed to the artist's advantage, it can still be difficult to navigate the brave new world of com-

munications, promotion, and connection, all the while making meaningful work. The necessity of both making and selling is still present.

It's a challenge to be a creative solopreneur who must keep up with a business *and* the shifts in technology and communications. It's a challenge to lose a reliable career one day and be your own boss the next. It's a challenge to market and self-promote, let alone price your creative work. It's a challenge to secure your own income and provide for a family. All of these challenges are real, but none are impossible to overcome.

Most of the business resources available to artists focus on career development: how to apply to a call to artists; how to prepare your artist statement and portfolio; how to connect with agents, licensers, and gallerists, etc. These resources, many of which are referenced in this book, are invaluable to professional artists. These resources satisfy a need in the professional career path.

This book, however, doesn't offer that type of advice. This book is about creating your own opportunity, and doing so by sharing your passion, talent, skill, style, story, and your unique vision of the world with others. You are the artist. You get to curate the experience people have with your art along with the life you envision for yourself.

BEING A SELF-EMPLOYED ARTIST IS AN ENTREPRENEURIAL PURSUIT.

In most cases, it is the entrepreneur who chooses to chart the course of action and navigate the waters. Artists who see their careers through an entrepreneurial lens enjoy the journey as explorers, but they also capitalize on opportunities that increase sales, elevate reputation, and impact their community. Artists who are proactive in shaping the life they want not only elevates their life and career, but also those of their immediate benefactors—family, friends, and

prospective buyers. For the creative entrepreneur, being a "starving artist" is never an option.

Yet some artists still believe the "business and marketing" side of a creative career will jeopardize creativity altogether. Not so fast—business and marketing can be done comfortably and authentically, especially when what you do provides value to other people. Being business-oriented increases your reach, productivity, and clarity in your goals.

In fact, the more opportunities your buyers have to connect with you and your work, the more likely you are to have consistent sales and enjoy established relationships with people who want you to be successful.

Furthermore, in a world that is hyper-connected, the modern day artist has the power to redefine what it means to be an art collector and to inspire "collector mentality" in any unassuming fan. Rather than selling to one-time buyers, independent artists can leverage social communications to cultivate relationships with people globally and encourage repeat sales.

This method of interaction is different from the old method that suggests you can make a work of art, but someone else must connect it to the world. Or, worse, you can make it and no one will know—a reality that all too many artists face. When either is the case, the feedback loop that connects the artist with his or her audience is missing.

The old model, and old model advice, keeps the artist in a cycle of waiting. Waiting for permission to sell at a higher price. Waiting for recognition in one's field and overall reputation. And waiting for someone else to reach out with an opportunity. The belief that the artist should wait for someone else's acceptance and rely on handouts serves no one.

The age-old adage, "Good things come to those who wait" does little to motivate, and it keeps those already in a

reactionary state from proactively pursuing better circumstances. Let's cross out the last word and change it to:

"Good things come to those who ~~wait~~ act."

Now here's a message that truly empowers. There's no time like the present. For self-employed artists, a "seize the day" mantra inspires action, making every day rich with possibility.

The new model is about creating your own opportunity by connecting with people who want or need what only you can offer. There's a market for your craft. Identifying your market is like modern day matchmaking: show up in a way that is true to you and make yourself available. At the same time, don't be afraid to pursue what you want.

If you want to elevate your creative career and make a better life, you must start with ambition and the belief that what you want to achieve is possible. Then, you must let it happen—you must let your creativity work for you so that you can enjoy the life you've made for yourself. This book is filled with ideas and strategies to help you do just that. Use these methods to create opportunities for your business, and more importantly, for your life.

YOU OWE IT TO YOURSELF AND THE WORLD TO SHARE YOUR ART.

Being creatively enterprising fosters leadership and community. The connectivity we have access to today has leveled the playing field, providing passionate people with an opportunity to share and shape the future.

Today, artists are crafting experiences and bravely putting them out into the world for others to enjoy, watch, read, use, jam to, riff from, purchase, fund, and learn from.

The Internet and social media have set the stage for dialogue to happen, which means you can bring your audience along with you and show it more than just the finished piece.

This also means that the process of making and marketing art is no longer confined to studio isolation until the next record, memoir, or series is birthed.

Instead, the creative process can be shared and experienced collectively to foster real connection and inspire opportunity.

Creative entrepreneurship requires risk-taking—but many jobs do. The difference is the sense of purpose you experience and the opportunity you create when you follow your heart. When you are meant to do something, not doing it has consequences too. You may end up being that starving artist after all, and worse, you may miss the chance to inspire and enlighten others with your unique vision of what could be. That is why I wrote this book: To help people expand their horizons beyond their comfort zones in a way that will enrich their lives and, through their artwork, enrich the lives of those they reach.

After studying art and design in college, I put my creativity to work in the world of architectural design. But as economic trends downturned, especially in the realm of building and urban development, I found myself unable to employ my talent with the firm I grew to love. Banks weren't lending; projects were being put on hold, and people like me were being let go.

As a result, I quickly identified that my skill set would need a strong complement—one that would either keep me employed elsewhere or set me up for an entrepreneurial life. I found my calling in an international business program that opened new doors for me.

After graduating with a dual-masters in Global Innovation Management and Business Administration, I paired art and business in the development office of a globally recognized

school for craft education. After that incredible job, I worked for the headquarters of a business consulting center.

While the center's expansive network provided invaluable business counseling to a variety of small business types, it lacked the special touch one must have in working with creatives. I saw my opportunity and decided to pursue consulting on my own, with a focus on the business of being an artist.

Today, I've worked with over 100 artists, helping them realize their creative profit and meaningful impact potential through my workshops and consulting program. My success is attributed to an over-the-top enthusiasm for my clients and a belief that with a little imagination—and planning—anything is possible.

This book is the result of my observations of what works in the business world that solopreneur artists can benefit from knowing.

Because the world is visual, social, and sharing, those with the artistic vision to capture the world and tell their version of it have a gift. Sometimes, the best way to maintain joy in sharing that gift once it becomes your business is to have systems and routines that support you, rather than cause you headache. That said, this book is designed to:

- *empower you with the knowledge of your own strengths and weaknesses because they will show up in your business.*

- *reveal systems that make the "business-side" more manageable, and give you measurable targets to aim for.*

- *encourage your creative flow and help you recognize when it's time to bring in some support.*

- *help you position your creative offerings for the markets that will support your livelihood and, therefore, support your creativity.*

- *let you establish unwavering principles that keep you grounded.*

- *help you curate an experience for your buyers and craft a brand that does the communicating for you.*

- *teach you to make the most of your network by fostering relationships and giving freely.*

- *support your creativity in your craft and in business with a routine that rejuvenates.*

- *invite you to create opportunity by adding value to the lives of others.*

- *and, of course, set you up to Let Your Creativity Work for You.*

So, make your art, hone your style, build your repertoire, and keep showing up. If and when you bring other people into the equation, e.g., customers, know that you can use your artistic talents in service of others without compromising who you are. Embracing an attitude of creative problem-solving and opportunity-seeking will help you differentiate between work that gets you paid and work that fuels your spirit. When your work does both, you're in a good place.

A favorite quote of mine, shared with me by the woman to whom this book is dedicated, is from the Pulitzer Prize-winning poet Mary Oliver, who says, "The most regretful people on earth are those who felt the call to creative work, who felt their own creative power restive and uprising, and gave to it neither power nor time."

Sometimes our creative power is powerless, not because we don't take action, but because we cannot see the path for taking action. Throughout this book, I will share stories and pieces of advice from artists and creative entrepreneurs who

exemplify success in many ways, though none would say their work is finished.

They have employed planning, research, and strategic goal-setting to move from Point A to Point B. They have carefully documented their processes, evaluated what worked, and thrown out what didn't. They have taken brave steps to tell their stories, share their work, and listen for feedback. They have crunched numbers, secured funds, and rerouted when necessary.

For the artists featured in this book, creative work is a constant. I encourage you to follow them on social media to see what they do next. I hope their wisdom inspires you and models the path for your creative energy to manifest and find its footing.

I know this book will be read by a variety of readers who are in different phases of their creative career. By using the words "artist" and "creative solopreneur," I hope to speak directly to you and anyone else who wants to turn his or her creativity into opportunity.

Remember—long-term success requires that you be your best self. In doing so, you will share your passions with genuine enthusiasm and foster meaningful relationships. And, to achieve the success you desire, it is critical that you cultivate an altruistic, entrepreneurial mentality, and be open to opportunity.

As you proceed in reading this book and using it as a tool, here are some ground rules to keep you focused rather than overwhelmed:

1. *Keep it simple. Just like in your creative work, sometimes less is more.*

2. *Take what you need. If you feel overwhelmed at any point in this book, take what you need at the moment. The rest will be waiting for you when you return.*

3. *Keep an open mind. Some of the topics covered in this book may require a significant shift in thinking. Stay light on your feet and in your thoughts as you absorb what is available to you in your reading and in the exercises.*

In many of the chapters, website URLs are given as references. If the URL links are no longer active, remember: Google is your best friend and should help you find what you are looking for.

My goal is to empower you with the right questions to ask, places to find information, and frameworks to operate in successfully. So take notes—in fact, write directly in the pages. Do the exercises and see what results. Scribble and doodle in the page margins and on the *visualize* page at the end of several chapters.

Don't be afraid to take your learning to the next level on your own. And please, keep the audience feedback loop open by sharing your reading experience with me.

So, are you ready to dive in? Let's go.

PART 1:

Preparation

"And when we realize that our true Self is one of pure potentiality, we align with the power that manifests everything in the Universe."

— Deepak Chopra

START WITH THE END AND WORK BACKWARDS

They didn't have professional development classes when Jason Hoelscher was an undergraduate. In fine arts studies courses, the notion of combining artistic skill development with career and income opportunities remains, as it has historically, off limits.

So it goes without saying that ambition and the timely realization that he would have to determine "what's next" on his own, prompted Jason to engage his future self to find direction. It was 1996, and he was finishing his BFA in Denver. As he prepared to enter one of life's many transitional phases, he was confronted with the choice of sitting back to wait for something to happen, or pursuing an uncharted path into the unknown. He chose the latter.

Jason set up a plan that in five years he would be showing in the top gallery in that area of the country. His plan became a single intention that directed his actions and gave him a target. A five-year goal gave him a starting point from which to work backwards.

1

To learn more about Jason Hoelscher, visit Jason-Hoelscher.com.

By setting this intention, all of Jason's efforts were pointed in the same direction. He showed up at different art show openings, networked with other artists and gallerists, and researched as best he could to familiarize himself with the market environment.

As a result of showing up, Jason found and took opportunities that got him closer to his goal. He submitted work to a student show and was accepted by Robin Rule, the juror and owner of Rule Gallery. Motivated and inspired, he spent the next month making new work and developing slide sheets. He got a haircut and a suit, and in April of 1997, he went back to Rule Gallery with the sole intention of showing Robin his new work.

Though he was intimidated and scared to death, Jason showed up prepared. When he left the gallery meeting, he left as the newest addition to the Rule Gallery roster. He had his first solo exhibition there one year later.

While it may have seemed like a stretch that he would get into one of the best galleries in town so soon, Jason set out with clarity in his intentions and kept his eyes open. He could have stopped with the juried show selection, but what he really wanted was gallery representation. It may have helped that he was a budding artist, unjaded and energetic. But he struck while the iron was hot, and in doing so, condensed his five-year plan into a year-and-a-half. This action set him up for future opportunities and began a career domino effect in which one opportunity led to the next and so on.

Jason's career is a result of preparation and a little luck. Now, he shares his experiences with his students as he pursues other milestones. When asked what one must do to be successful, he shares the following:

1. You must be strategic in your approach.

2. You must do your research.

3. You must be in it for the long haul.

Within two years of his Rule Gallery exhibition, Jason exhibited work in New York and has since exhibited in Paris,

Berlin, Hong Kong, Santa Fe, Miami, and other major cities. His work has been reviewed by notable publications in his field, and he maintains representation and collector relationships internationally.

In addition to painting, showing, and selling, Jason teaches, writes, reviews, and participates. He makes his living in the arts and has used the power of intentionality to direct his career choices.

THE POWER OF INTENTIONALITY

Jason's story is one that resonates with anyone who has ever had a goal that required guts, research, and some planning to make it happen. He knew what he wanted, and he manifested that desire into reality.

Knowing what one wants is half the challenge. There is power in knowing what you want. It's the difference between passively experiencing life and floundering, versus moving forward with direction. The latter option creates purpose and gives meaning to one's work—whether it takes a year-and-a-half or ten years to happen.

When you know what you want, you can start to create the vision, or the under painting, for what it looks like. When you don't know what you want, you have nothing to aim for. It is impossible to infuse intentionality into planning because there are no plans.

Most of the artists I work with are self-employed. Some have maintained their livelihood through their craft for many years while others are just beginning to do so. However, they all have one thing in common—they are all in some form of transition and desire something more.

Before I begin a year of transitional consulting with my clients, I ask them to reflect on two things:

- *What do you want your career to become in the next one, two, and five years?*
- *What are your BHAGs (Big Hairy Audacious Goals)?*

Some people come up with responses right away. Others need more time to reflect, but this exercise is never for me. My job is to help bring awareness to their desires. Without this critical step, we have nothing from which to work backwards and nothing to plan for.

LET YOUR BHAGs GUIDE YOU

We all have BHAGs. Some call them desires; some call them dreams. Some people are highly motivated by monetary rewards while others need a different type of motivation, like sense of purpose and contribution.

BHAGs are the motivators that drive us to wake up every day and keep at it. They are the reminders when we forget and ask ourselves, "Why am I doing this again?" Our BHAGs are our raison d'etre, the mark we will leave when we are gone. BHAGs are our legacy. They are the things and people we care about that inspire us to be better people.

The concept was developed by authors Jim Collins and Jerry Porras in their book, Built to Last: *Successful Habits of Visionary Companies.* While their idea was pushed onto employees back when the manila folder and the fax machine were popular, it still rings true that we are most motivated by what is inside our hearts.

I was first introduced to BHAGs by a marketing strategist named Martin Smith whose career has been shaped by many variations of turning creativity into profitability. Martin had a big hand in the success of the Magnetic Poetry kits that spread like wildfire across American refrigerators in the mid-1990s.

He has brought in millions of dollars in revenue for companies through sophisticated digital marketing, has broken online sales records, and even worked with legendary photographer Annie Leibovitz at one point in his multifaceted career.

Despite his highs and successes, Martin is motivated by a singular goal like no other before. He wants to find a cure for cancer. Finding a cure for cancer is Martin's BHAG—one he shares with countless others. As a survivor of chronic lymphocytic leukemia (CLL), a rare cancer of the lymph nodes and bone marrow, Martin started "Martin's Ride to Cure Cancer"—a sixty-day trans-American bicycle ride to raise awareness and funds for cancer research. In a single summer, he raised $27,000 through cycling and has gone on to found the *Story of Cancer Foundation*—a crowdfunding website for cancer research.

Martin's BHAG is his passion. His mission carries with it a sense of urgency because the work he puts in today has the power to help millions of people. In his CureCancerStarter. org video, he tells viewers, "It's time to start living right now. And getting things done right now."

Martin is highly motivated by something much larger than himself. Yet not all goals worth pursuing have as wide a reach. As we've seen in Jason and Martin's goal setting, BHAGs come in all shapes and sizes. The act of explicitly stating your BHAGs to yourself and, in some cases, to the world around you, validates possibility.

In my own interactions with artists, I've heard people give voice to what really matters to them. The common thread these artists share is that their goals are worth working hard for and remain the focus of their immediate plans.

Here is a selection of what I've heard people say are their driving desires:

I want...

- *people to know what is really happening in underserved communities through my photography.*
- *to collaborate with those I admire.*
- *to make cities more livable and more beautiful for people.*
- *more time in the studio to create my art, and I want people to be inspired by it, live with it, and find as much joy in it as I do.*
- *to start my own jewelry business, and get my pieces into high-end boutiques.*
- *to work on my own terms with people who appreciate quality.*
- *to challenge the world's view on nationality and identity.*
- *to send my kids to college without financial worry.*
- *to enjoy travel and explore the world.*
- *to share with others through teaching.*
- *to publish my own project book.*
- *to enjoy financial independence and the choice to continue working for someone else or myself.*
- *to bring people joy through my art.*

You've probably heard an earful about goal setting and intentionality from other sources. Perhaps you've blown it off as a clichéd, soft approach to doing things. However, I would argue that you've set goals before and have seen results. When has goal setting worked for you in the past?

When was the last time you took stock of the present and created goals for the future?

The time to do so is now, because what you do today sets you up for what happens in three months, six months, one year—even five years down the line.

For anyone in transition, the same sense of urgency Jason undoubtedly felt as an undergraduate seeking his next steps likely exists for you, no matter where you are in your life. Transition is unsettling, but it is the vehicle that brings about change, often for the better.

If you feel a compelling desire to serve others through your work like Martin does, your vision can have an impact no matter how long it takes, but the time to start is now.

If visualizing the journey doesn't come naturally to you, think about your priorities and the people you care about. What does happiness mean for them? What does happiness mean for you?

Think about what you want to draw into your life. When you know what you want, you can manifest it in your life. Some people call this the Law of Attraction—when you focus on what you want and you believe you can have it, the Universe will deliver it to you. This mentality lends itself to the Law of Abundance—there's enough to go around; there is plenty for everyone.

This is not to say that pursuing your dreams will paint your world in rose-colored glasses. Anything worth having and worth experiencing takes effort. Similarly, to know what you want is not intended to be a selfish act. In fact, knowing what you want can be helpful to others too.

So reader, let me ask you: What do you want? What are your BHAGs?

The rest of this book revolves around your business and your life's desires. If you gain nothing else from these pages, at the very least find a sense of your work's purpose for yourself.

For now, I invite you to get comfortable and create a judgment-free zone in which you can release your inhibitions and be honest with yourself.

Ask yourself, "Self, what are your heart's desires? What are your Big Hairy Audacious Goals?" And write them down.

MY BHAGs

Letting your BHAGs guide you creates an entrepreneurial instinct that makes your priorities your driver. This in turn provides clarity in decision-making, and gives purpose to creative work that may at times feel isolating.

When your BHAGs guide you, your outlook shifts to what is possible. Your cup is full, slowing you to trust your instincts.

You find solutions and learning opportunities through problems, and sweat equity becomes fun. Fears turn into challenges worth overcoming. Competition becomes collaboration; opportunity is everywhere.

This mind-shift has the power to move you like a freight train busting through the creative blocks in your path.

Much like in the creative process, when you are intentional yet open, and you welcome serendipity, opportunity finds you (or you find it). Serendipity shows up in your artwork when you don't know how to finish a piece and then a single moment shows you how. Serendipity can also show up in your business and in your relationships, especially when you know what you want.

Knowing what you want can help you when you are faced with options that could derail your focus. Discriminating between opportunities that align with your vision, and those that distract, can save you time and money. Knowing what your big picture goals are can insulate you from distraction.

Let yourself be reminded every day of what you are working toward, why it matters, what it's worth to you, and why you shouldn't give up.

5- 2- 1- YEAR SNAPSHOTS

Like any New Year's resolution that channels your energy and time into a focused direction, a little planning goes a long way. Start with the end and envision the results of your efforts. Envision your big picture goals as realized. Who is there? What does it look like? What matters most?

Starting with the end and working backwards, what needs to happen in the next 1, 2, and 5 years to make your vision a reality? Start with a 5-year snapshot and work your way into the next 365 days.

For example, let's say you want to leave your job and become a full-time, independent artist, earning the same income you earned at your job prior to leaving. Take the time to write

your own 1, 2, and 5-year snapshots specific to what you want and use the sample scenarios as examples.

5-YEAR EXAMPLE SNAPSHOT:

> *Enjoying life as a full-time artist and earning a salary equal to or greater than my last job. Cultivating buyer relationships internationally. Selling originals and commissioned pieces from my studio and from my website. Supporting my favorite charity as a contributing board member.*

My 5-Year Snapshot Looks Like This:

2-YEAR EXAMPLE SNAPSHOT:

Working out of a studio with high visibility to the public. Leaving my full-time job after I reach the milestone of earning at least half of my desired salary from sales of my artwork. Communicating with collectors and new customers regularly through social media and email marketing. Showing my artwork in solo, two-person, and group shows locally and in other cities. Receiving press and media attention quarterly, and contributing guest blog posts to well-read blogs.

My 2-Year Snapshot Looks Like This:

1-YEAR EXAMPLE SNAPSHOT:

Setting up a professional artist website that lets me sell directly to new customers and collectors. Completing a body of work to show as a part-time artist; still employed full-time elsewhere. Taking commission opportunities and earning one quarter of my desired salary from sales of my artwork. Researching places to show my work, reading arts publications and related blogs, and developing relationships within the arts.

My 1-Year Snapshot Looks Like This:

..

..

..

..

..

..

..

..

..

..

..

..

DEFINE YOUR OWN SUCCESS

To be successful in your pursuits, you must define success on your own terms. Pulitzer Prize-winning author Anna Quindlen reminds us that, "If your success is not on your own

terms, if it looks good to the world but does not feel good in your heart, it is not success at all."

Every definition of success is different, and every small success builds upon itself. Creating your first series of ten pieces, necklaces, quilts, or photos is just as important as creating your first fifty. When you pass a milestone that contributes to your success, there will be other milestones to pursue. Successful people never stop aspiring because there is always something more to be desired, something more to do, more people to reach, more lives to touch, etc.

What you want your career or business to be in 1, 2, and 5 years may change. Because the path is never linear, exposure creates learning opportunities that inform your next steps. As Martin Smith said, "The process is important. The discovery only happens when you get free with it. Learn as you go, but at least go." In going, you may be more prepared to let your creativity work for you than you realize.

> If you are a Tweeter, use #LYCWFY to share your intentions. Feel free to send them my way @HeatherEAllen

#LYCWFY INTENTIONS IN 140 CHARACTERS

The final exercise in this chapter is to set an intention for reading this book. By doing so, you'll hold yourself accountable and create action out of inspiration. If you want to take your intentions a step further, share them with the world in a 140-character tweet.

My 140-character tweet:
 "I'm reading #LYCWFY because _____

_____.

As you read, the exercises and stories in this book will help you create the vision. Write the plan. Design the blueprint. Paint the painting and step into it.

"Hold fast to
dreams,
for if dreams die,
life is a
broken-winged bird
that cannot fly."

—Langston Hughes

LEVERAGING YOUR STRENGTHS BY KNOWING YOUR STORY

For many adults, childhood and young adult experiences create the foundation for how we view and interact with the world. For Elaine O'Neil, growing up in rural Maine conjures up memories of picking wildflowers, playing hide-and-seek in the barn, and swinging with siblings on ropes from trees as the sun melted below the horizon.

Summers meant the sound of popping wood from beach bonfires at night, the taste of blueberries and fresh produce, the scent of clean clothes and sheets drying on the line, and the feel of rubber banana bike tires hitting all the bumps as she sped down the road, kicking up dirt as she went.

To learn more about Elaine O'Neil, visit ElaineONeil.com. Follow her on social media at Facebook.com/ElaineONeilTextileArtist.

Indoor life meant colors, textures, patterns, and lines stored in the fabric closet underneath the stairs—piled high with fabrics of all kinds just waiting to be chosen for a project that would occupy the entire dining room table.

These sensory and tactile memories are the carbon fibers of what was imprinted early on, yet remain in her adult life as an artist. Elaine's experiences of growing up in an idyllic setting surrounded by nature and fun show up in her textile collage pieces. "I carry that feeling with me and try to invoke in my work a sense of place," she explains.

After her early years of sewing slipcovers as a means to support her artwork, Elaine had enough consistent commissions coming in to say goodbye to slipcovers, making textile collage art into her full-time work.

Elaine had the timely fortune of developing a skill and mastering the tools, techniques, and materials needed to pursue her craft early on. But in her career, she may be most fortunate to have developed a signature style quickly and naturally: quirky, whimsical, crooked, and playful. Happy.

Stories and experiences from childhood inform Elaine's outlook on life and manifest in her craft. Because she is able to capture positive associations with sense-of-place works, people find meaning and value in her pieces and commission her uniquely Elaine O'Neil style for their own one-of-a-kind pieces. As a result, Elaine's textile collage artworks are carried in the permanent collections of colleges, universities, and hospitals, as well as the homes of national and international collectors.

The commerciality of Elaine's artwork is approachable and easy to understand because her story and style are relatable. Relatability gives her work a level of commerciality that easily translates to merchandized products and illustrations in books. In doing so, the medium changes but her style remains the same.

Like Elaine O'Neil, every artist has a story that influences his or her style and artwork. For some, storytelling and sharing comes naturally, but for others, it can be more difficult to articulate. The same is true of developing one's style. While it is challenging to tell one's own story, having a well-articulated story and style can make the difference between selling and not selling.

Experimenting with medium, subject matter, and material helps you to develop your style, but how do you take that knowledge, infuse your story, and talk about your artwork? How do you write about it?

Here is where dissecting the underlying subtext of your work becomes useful. Despite the fact that very few people are happy with their self-written artist statements and biographies, we all have stories that support the work we make and can help audiences and grant reviewers to understand the work better.

Storytelling helps people to connect with you as the artist. Never underestimate how much story contributes to your work. Though some artists make work that is void of personal narrative, people are often just as fascinated by the artist as they are the artwork.

"YOUR STORY, YOUR SUBTEXT" EXERCISE

Whether it's your story or someone else's, story creates the subtext of your artwork. Story also provides your audience opportunities to connect with you to foster a deeper, more meaningful relationship with what you make. The following three-part exercise is designed to bring some of your story to the surface through words.

If you are stuck in a rut trying to come up with your artist statement, feel out-of-sync with your creative roots, or just want to test a new process for writing about your work, I

encourage you to set aside time (roughly 45 minutes to one hour), to allow yourself to be guided through the exercises.

Grab a pen or pencil and a timer. Find a comfy place to get in "the zone" and be guided, allocating the suggested amount of time for each response. Because this exercise could go on indefinitely, time constraint gives you a starting point and a stopping point.

Part 1: At Least 20 Things (15 minutes)

Much like in the creative process, you'll begin by collecting a lot of pieces that will inform the whole. Set your timer for 15 minutes and walk through your memories, starting with the earliest. Use the blank space to list at least 20 things that stand out as being memorable in your life. These things can be people, places, experiences, tactile objects, sensory memories, traditions, interests, etc.

..

..

..

..

..

Part 2: Themes of Meaning (15 minutes)

Now that you have a page overflowing with points of influence in your life, group them into themes. The parts of your story you've chosen in Part 1 may reveal patterns and commonalities.

For example, you may notice that different geographic locations stand out as significant, so you would group them into a one-sentence theme:

"Travel and moving from one location to another."

Or you may see the names of people who have had some effect or influence on you, so you would group them into a theme:

"Community, network, and connections."

Or you may see that outdoor elements and nature show up repeatedly in your list, so you would summarize them into a one-sentence theme:

"Observing flora and fauna, and experiencing nature."

To help you create your own themes and get your wheels turning, here are a few more theme examples:

- *"Creating order out of chaos."*
- *"Nostalgia, and longing for a time gone by."*
- *"Balancing contrasting emotions."*
- *"Peace, joy, and laughter."*
- *"Fact being stranger than fiction."*
- *"Sense of humor and lightheartedness."*
- *"Family tradition and meal times."*

Set your timer for another 15 minutes to process your list into one-sentence themes using the bulleted spaces provided for you.

-
-
-
-
-
-
-
-
-
-

Part 3: Themes of Meaning Manifested (15 minutes)

While the individual elements of art (line, shape, form, space, texture, value, and color) may not translate literally to your themes of meaning, there are elements in your work that show up repeatedly like the patterns in your life. The elements in your work may be there for a reason.

Looking at the *themes of meaning* you've identified, take the next 15 minutes to respond to how these themes show up in your artwork and in your aesthetic, choice of materials, subject matter, and the elements of art as they apply to your work.

-
-
-
-
-
-

In working through the exercises, you may see parallels between the influences in your life and the elements that show up in your artwork. Any themes that prevail in your work are worth noticing.

YOUR ARTIST STATEMENT

For many artists, writing an artist statement is a daunting task. It's difficult to narrow down an entire lifetime into a few paragraphs.

Writing an artist statement is a self-reflective process that provides the artist with documentation that serves as a chronology as the artwork evolves.

An artist statement also becomes a means of focusing thoughts and ideas into words that make it easier to discuss what is visual—the artwork itself.

> The book *ART/WORK: Everything You Need to Know (and Do) As You Pursue Your Art Career* by Heather Darcy Bhandari and Jonathan Melber is an excellent professional resource for visual artists who want to show in galleries and write that statement.

TIP: Include your website at the end of each of your bio types (i.e., For more information, visit MyWebsite.com).

By now, you have a lot of material to pull from, including your inspirations; your style and aesthetic; the medium and materials you use; the origin and meaning behind the works you create; and your reasons for creating. You have enough elements to piece together a statement by using the framework of the *Your Story / Your Subtext* exercise.

A good rule of thumb is to stick to 2-4 paragraphs that occupy no more than a page. If you are making a statement about your artwork in a general sense, let that be your focus. If you are making a statement about a specific project or series of work, focus there.

BIO, SHORT BIO, SOCIAL MEDIA BIO

Another piece of self-storytelling that accompanies one's creative work is one's biography. It allows people to understand a few of the events that shape an artist's vision. It's often helpful to read the biographies of the artists you admire to gain exposure to autobiographical language.

If you find that writing about yourself becomes an excruciatingly difficult process, you're not alone! Consider reaching out to someone with strengths in writing. A good copywriter or copy editor can pull out the important parts of your story and help you construct a worthwhile narrative.

Most artist bios stick to the same length rules as the artist statement: 2-4 paragraphs that occupy no more than a page. The most important factor in writing your artist bio is your audience. Who is reading your biography? What information can you share with your readers to support your artwork?

A gallerist reading an artist bio has certain expectations, but those of buyers and collectors may be different. If you intend to sell directly to buyers (customers) and want to cultivate collector-level relationships with them, give your biography the personable details that will help collectors connect with you.

It is best to be prepared with a variety of biography lengths to cover the gamut of submitting bios along with applications, providing speaker bios when you're invited to speak, sharing a snapshot of who you are in the world of social media, etc.

Use the space below to write your long bio, short bio, and social media bio. Or take to your trusty notebook to write a few rough draft bios first, and return to this page when you are happy with what you have written. Keep in mind, a biography is a living, evolving history, and no biography can tell your story perfectly.

Your Long Bio

(2-3 paragraphs up to 500 words)

Your Short Bio

(One paragraph, no more than 100 words)

..

..

..

..

..

..

..

..

..

..

..

Your Social Media Bio

(No more than 2 sentences or 25 words)

..

..

..

..

A BALANCING ACT: STRENGTHS AND WEAKNESSES

As much as discovering the underlying subtext of your work is critical for any artist, discovering one's internal strengths and weaknesses is critical to any artist in business.

The strengths and weaknesses conversation is among my favorites for realizing self in group and team dynamics, but strengths and weaknesses play a big role in independent work too. These two opposites come together to inform us of what we've got to work with and where we might want to bring in some outside support.

No matter how you look at it, self-awareness of individual strengths and weaknesses benefits everyone. Creative entrepreneurs and business owners in particular can benefit from self-knowledge as a means of increasing efficiency in self-driven operations—which makes a high level of self-awareness a business asset. This knowledge is a critical part of letting your creativity work for you.

The truth is you don't have all the time in the world to figure everything out. However, to maximize the time you do have, strive to operate from a place of strength and know yourself best.

To summarize business guru Peter Drucker (1909—2005), a person can perform best from places of strength. What does this tell us? The more we know about ourselves, the better prepared we'll be to be our best selves, operating with our strengths and talents at the core of what we do.

Strength Finding

Knowledge, skills, and practice are the pillars of strength for many performing and visual arts practitioners. In his book, *Strengths Finder*, author Tom Rath says, "Without basic facts in your mind and skills at your disposal, talent may go untapped.

Fortunately, it's easier to add knowledge and skills to your repertoire, but turning talents into real strengths takes practice and hard work."

Rath presents readers with *The Strengths Equation*:

Talent x Investment = Strength

This equation brings commitment and dedication, in the form of investment, to the forefront. Investment is what separates the average from the best. So, if your talent is your passion, pursue it obsessively and do the best you can to take yourself from good to great.

An Asset in Identifying Weaknesses

Being aware of your weaknesses, also known as your areas of "lesser talent," is an essential part of developing strengths. That is not to imply that weakness should be developed equally with strengths, but rather that awareness of weaknesses further elevates strengths.

Operating from a place of strength and joy is at times akin to running on autopilot and enjoying the ride—it comes naturally. If you do what you love, you will love what you do. Operating from a place of weakness, while necessary at times, can stunt creative flow, making work just that. Work.

In both situations, opportunities exist to challenge one's self and grow. Operating from strength isn't always easy, but you are more likely to put in the effort in your areas of interest.

Having an honest acknowledgment of your weaknesses, particularly in business, can open doors. The more you know, the better prepared you are to form alliances and find the right partnerships to keep you moving. Niche specialization means there's someone out there with the right skill set to help you in your areas of weakness. That someone may just need your specialization to make up for his or her weaknesses too.

The next exercise credited to business consultant, Albert S. Humphrey, will help you identify strengths and weaknesses so you can use them to your advantage in your business. The exercise, which is the first part of a <u>SW</u>OT (<u>S</u>trengths, <u>W</u>eaknesses, Opportunities, Threats) Analysis, will give solopreneurs and business partners an internal inventory of what skills are available and where you may want to bring in some support.

For those in a business partnership with two or more teammates, complete the following portion of the <u>SW</u>OT Analysis for your creative business separately. Find space away from each other, and channel your observations of the strengths and weaknesses that exist in your business into the space provided.

You may consider the strengths and weaknesses of individual partners. You may also consider how the group dynamic contributes to the team's strengths and weaknesses. What areas are covered? What areas are lacking? The key word for everyone to focus on is "team." Keep in mind that the strengths and weaknesses are shared as a whole—there should be no blame, but rather a communal drive to be even better, together.

Once you've spent time drawing from your own experiences, come back together as a team or group to visit your notes together and compare. A strength you can add to the top of your list right now is the inherent benefit of operating with multiple skill sets in collaboration.

For solopreneurs operating independently, follow the same set of instructions: find space to be alone and channel your observations of your creative business strengths and weaknesses, as objectively as possible, into the SWOT Analysis. It may also help to consult with a trusted friend or confidant who knows you well, whom you trust and whose opinion you value, to add his or her observations to your list of strengths and weaknesses. In completing this exercise, you will find a few key areas in which you may want to delegate or outsource tasks.

SWOT ANALYSIS

PART 1: An Internal Baseline for Solopreneurs & Partners

strengths (internal)	weaknesses (internal)

Look at your list of strengths and weaknesses, and remember, this exercise is intended to draw attention to areas of talent and areas of lesser talent in your business. Knowledge of your strengths and weaknesses helps you focus on what you do best and brings awareness to the areas you may need help in. Unless you want to wear all of the hats in your business use this knowledge of self to bring in support so you aren't working yourself ragged.

visualize

"I like things to happen; and if they don't happen, I like to make them happen."

— Winston Churchill

CHAPTER 3

ORGANIZING YOUR BUSINESS FOUNDATION FOR SUCCESS

As rare as many people think it is to be a "whole brain" learner, plenty of creative, right-brainers learn to engage their left-brain within their creative work. Take for example, budget-oriented artists who determine their return on investment (ROI) before they begin a new series of artwork, time-sensitive performers who can manage people and projects, and analytical vocalists who create sequences and patterns in their lyrics.

Similarly, there are left-brainers who engage their right brain, such as defense attorneys who play guitar in a band on the weekend, scientists who pour hours into making bowls

To learn more about author and illustrator, Jonathan Miller, visit SammyDogBooks.com. And find him on social media:

Twitter.com/ SammyWonderDog

Facebook.com/pages/ The-Adventures-of- Sammy-the-Wonder- Dachshund/45723192692

from the potter's wheel in their garages, and accountants who indulge in energy-flow movement and modern dance.

I believe we are all whole brain learners, and as we age, our natural tendencies and interests align us with the things that become our strengths, including our strengths in learning style.

Because our brains are malleable and can be molded around fresh stimuli, it is possible to learn new things at any age—whether we think we can or not.

By using a mind over matter philosophy that positively affirms, "I can do this," it is possible to develop a profitable business from your creative work because in doing so, you will be adding value to the lives of others while staying true to your authentic self.

Jonathan Miller found a means of doing just that when he discovered how to turn his paper illustration artwork into a valuable, fun experience for young readers. Jonathan is the author and illustrator of the book series, *The Adventures of Sammy the Wonder Dachshund*, which currently includes three hardback titles.

Jonathan spends over twenty-four hours making each individual page, meticulously cutting paper pieces that create a narrative for children, parents, and teachers to enjoy. He arranges the colors, creates depth, and adds texture to fill every page with imagery.

Jonathan is a self-producing artist and self-published author. He is responsible for planning, budgeting, purchasing, promoting, distributing, and selling his artwork.

How does one person wear so many hats *and* create a sustainable living that brings joy to the lives of others and inspires enough momentum to keep production going? It's not easy, which is why Jonathan starts with a business plan.

To learn more about his whole-brain process, I asked Jonathan to respond to a few questions.

Heather: How did you find your style and enthusiasm for the main character of your work?

Jonathan: My main character, Sammy, is inspired in one of three ways. He is loosely based on me in some situations. Students give me ideas of what they'd like to see Sammy do next. Or I'll see people do things and think, "Wow, that'd be funny for a wiener dog to do."

Heather: What was the career tipping point in which you felt you could confidently forge ahead as a full-time author and illustrator?

Jonathan: Well, I fought being an artist for as long as I possibly could. It's what my mom always wanted me to do, but as I got older, I associated being an artist with eating soup for the rest of my life. I went to college for business but kept coming back to wanting to do something fun and creative for work.

I started thinking about making a children's book, so I sat down and wrote out a business plan for my book. It was then that I realized this was something that financially made sense and that could work. Once I had finished my business plan, I cut the cord from my job. I knew I would never be happy doing anything else, and that's what drove me to take the chance.

Heather: How does a business plan help you prepare for the making, marketing, and selling aspects of your creative work? And how does such a plan help you define and measure success?

Jonathan: First, it helps me understand how many books I need to sell to recover my investment in each book and what I need to sell just to pay the bills. Secondly, it helps me set sales goals. A business plan also sets up a sort of checklist.

In addition to lists of places to sell the books, I come up with a list of marketing ideas for each book—blogs, social media, etc. Some things I do with the release of each book; some are ideas and strategies I implement over time.

The business plan for me acts as a road map and checklist to keep me on track with my goals and what I want to accomplish with my time and resources.

Heather: Do you work with anyone else besides Sammy?

Jonathan: I work with a graphic designer to lay out my books and handle some marketing materials for me. I work with a web designer to set up and do maintenance on my website. And I work with a person who helps me collect information for school visits. I work with all three people on a pay-per-job basis. This is helpful because it allows me to get a wide variety of things done in a cost-effective way.

Heather: What are your favorite parts of your job?

Jonathan: I love the actual act of creating a book. I love coming up with promotional things and everything associated with releasing a new book. My favorite thing is sharing the books with school children. I talk to them about reading, writing, art, and book making. The school visits are one of the most rewarding parts of the job.

Jonathan's creative work is thoughtfully planned, and thoughtfully executed. Your creative work can be too.

After identifying BHAGs and strengths, there's nothing like having a solid foundation for turning creativity into business opportunity, and allowing that creativity to work for you.

It doesn't matter what phase you are in your business—planning can be done at any point. In Jonathan's case, each book receives a business plan of its own, prior to publication. He treats his books as individual projects and dedicates time to marketing and selling the books once they are produced. His book business plans give him predictability for when he will see a return on his investment, and they help him measure success.

In this chapter, we'll discuss where to focus your business energy and how to set up a one-page business plan for a given project or year. From there, we'll bring in opportunities to systematize and automate the activities that support your business, particularly those you'd prefer to outsource.

With a plan in place, it is easier to navigate the business and spend time doing what you love to do. When you have a plan, everything else falls into place.

THE VALUE OF A ONE-PAGE BUSINESS PLAN

I prefer the one-page business plan, especially when it comes to solopreneurships. Just as a number of different types of activities exist in a business, there are also a number of one-page business plans to help creative solopreneurs stay focused. Business planning reinforces intentionality, allowing you to be less reactive and more proactive.

Such a tool is likely to be useful for the independent business owner, for a number of reasons. First and foremost, it is concise and to the point. Designed to be brief and bulleted, a one-page business plan is a snapshot of:

Are you thinking of starting a business? Visit HeatherAllenOnline.com/resources for a few of my go-to small business tools.

Want to take your art business further? Visit ArtBusinessOnline.com.

> Hint: In completing all of the exercises in this book, you will have developed a full business plan for your business.

- *what you do, make, and sell for profit.*
- *who your target audience is for buying what you do, make, and sell.*
- *where you can find that audience.*
- *how you will communicate with your potential customers.*
- *what you want to gain from your efforts.*

The short and sweet nature of a one-page plan is generally easier to approach than a fully developed, multi-page plan, and thus, it is more likely to be used by an individual business owner. In an age when new technology or social media platforms can shift a business's activities overnight, business owners benefit by having flexible plans that allow them to remain agile. Think of your one-page business plan as a living document that evolves with your business.

Second, a one-page business plan gives the business owner a snapshot for seeing the whole and elaborating on the parts. While a one-page plan can be very powerful, it is little more than the table of contents for a book. If you want more information on a particular topic, like the marketing plan or the revenue plan for your business, you can develop those sections and refer to them when you need them specifically.

Third, a one-page business plan is made for the business owner, not for the hypothetical investor or banker since neither is a likely candidate for studio art and craft business funding. A small business owner who has zero intention of seeking venture capital funding or selling a business needs a plan that is tailored to the business owner's needs as opposed to one that is tailored to the needs of an investor.

Treat your one-page business plan as your outline for more comprehensive planning, and use it as a tool to promote creativity, profitability, and predictability. Think about your experiences in selling your artwork and bring in the interactions you've had with customers, retailers, galleries, etc.

Keep an eye on how your current activities align with where you want to be.

THE CREATIVE SOLOPRENEUR ONE-PAGE BUSINESS PLAN

As in Chapter 1, create your business plan by starting with the end and working backwards. At the end of the year, what do you want to have happened in your business?

The Creative Solopreneur One-Page Business Plan is adapted from Alexander Osterwalder's Business Model Canvas. Use this tool as a strategic plan that guides your activities when you are lost or need focus.

Step 1: Vision & Mission. What is your personal vision for the business? And what is your customer-focused mission for the business? These two questions are very different because the first (your vision) addresses your desires for the business, and the second (your mission) addresses how you plan to add value to your customers' lives.

Step 2: Product & Service. What do you do, make, and share that translates into a product or service offering? This step includes physical, finished products like jewelry, and unfinished products like bead-making kits. It also includes the value of information sharing through the classes or workshops you could teach as a service.

Step 3: Year-End Salary. Where do you want to be financially at the end of one calendar year?

Step 4: Monthly Measurables. Divide your response from Step 3 by twelve to give yourself a target monthly revenue quota. If you are aiming for an annual salary of $45,000, your target monthly quota for paying yourself will be $3,750. Using a numerical target is a great way to measure success— numbers can't lie, and they create a solid benchmark for a month's worth of activity. Note: This number does not include

any costs or expenses; it is simply an example of the annual salary one may desire to earn.

Step 5: Market. Who are typical customers, fans, and buyers of what you offer?

Where are you likely to find customers, fans, buyers, and/or students? Another way of looking at this is: What is the best way for your customers, fans, buyers, and students to find your offerings? Your response to these questions will inform your marketing choices.

Step 6: Marketplace. Who else in the marketplace is offering something similar to your products and/or services? How are your potential customers, fans, buyers, and/or students finding that person's products and services?

Step 7: Marketing. How will customers, fans, buyers, and/or students find your offerings? What type of communication will they respond to?

Step 8: Channels & Distribution. How will you reach your customers, fans, buyers, and/or students? Through what means or vehicles will you sell your products and services? (Online sales? Boutiques and galleries?)

Step 9: Customer Relations. What expectations do your customers have of you, your business, and your product? How do you manage relationships with your customers and keep them engaged?

> Knowing your costs and expenses can help you reduce them.

Step 10: Revenue. What offerings could you turn into revenue streams? Start each bullet point with a verb ending in "ing" (i.e., teaching, selling, doing, speaking, making). What cost is your customer willing to pay for the value of each offering?

What percentage does each stream contribute to the overall revenue of the business monthly, quarterly, and annually?

Step 11: Costs & Expenses. What monthly, quarterly, and annual costs can you anticipate for your business? (i.e., utilities, materials, studio rent, website-related, expected marketing costs, travel, show booths, etc.)

Keep in mind that if you want a monthly salary of $3,750 for your personal income, you will want to add your business costs and expenses to your monthly salary to determine how much total monthly revenue your business needs to bring in. If your business brings in more revenue than what is required to pay your salary and cover costs, your business is turning a profit.

Step 12: Profit. Subtract your monthly costs and monthly salary from your monthly revenue to find your monthly profit. Subtract your annual costs and annual salary from your annual revenue to find your annual profit.

THE CREATIVE SOLOPRENEUR ONE-PAGE BUSINESS PLAN

1. VISION / MISSION.	
2. PRODUCT / SERVICE.	
3. YEAR-END SALARY.	
4. MONTHLY MEASURABLES.	
5. MARKET.	
6. MARKETPLACE.	
7. MARKETING.	
8. CHANNELS & DISTRIBUTION.	
9. CUSTOMER RELATIONS.	
10. REVENUE.	
11. COST & EXPENSES.	
12. PROFIT.	

A key benefit to approaching your creative career from an entrepreneurial mindset is that in doing so, you are intrinsically more open to opportunities that may have otherwise been perceived as off-limits. By using a judgment-free approach, you will benefit from seeing possibilities as limitless.

In the marketplace, anything you make, do, or share that adds value to others is valuable. When something is valuable, it can be bought, sold, and exchanged for equal value—often in the form of money.

What is unique about art and craft is the "maker factor." As the visionary, artist, and maker of what you create, what you make, do, and share is uniquely yours. No one else can do what you do quite like you. Hence, the fascination people have with the artist in addition to the art itself. Furthermore, value exists in the handmade, particularly when economic trends lean toward supporting local businesses.

Now is a good time to point out the delicate balance between art for art's sake and art for market sale. These days, both can exist simultaneously.

Take, for example, the company Artware Editions, which is committed to featuring—and selling—functional objects by visual artists. Through Artware Editions' eCommerce platform, www.ArtwareEditions.com, the artwork of well-known and well-respected artists is featured as products for sale at prices far more accessible to the average consumer than the artists' original works are.

On the website, you can find colorful John Baldessari beach towels, Damien Hirst tote bags, and Yoko Ono "Imagine Peace" water bottles.

That said, if you think that the marketability or commerciality of your work is getting in the way of, or jeopardizing, the purity of your art, it may be best to secure your income from other sources until your artwork is selling consistently.

Ultimately, you must determine for yourself what approach fits best with your BHAGs and your plan.

NAMING YOUR BUSINESS

Naming your business is an important part of the business start-up process. In choosing a name, it's best to think of your audience and how quickly those people will understand the core of what you do.

In naming your business, respond to the following questions:

- *What name will your target audience understand and remember?*
- *What words will people search for to find you?*
- *Is the URL available for the name you want?*
- *Is it important to include your name in your business name?*
- *Is it important to include your medium in your business name?*
- *Do you want to convey a concept or a personality in your business name?*
- *Do you want to build a brand around yourself or your craft?*
- *Do you have a physical storefront or studio that is key in your business branding and naming?*

- *Do you provide physical products? Services? Both?*
- *What business names have other artists with similar offerings used?*

You may have an umbrella business name for tax purposes in addition to a "doing business as" (DBA) name for the public. For example, your official business name may be Your Last Name Art, Inc. but your DBA may be "Portraits By Your Name."

In either case, you'll need to register your business name with the Secretary of the State in the state in which your business is registered, along with the city and/or county Register of Deeds.

Another useful resource for naming a business is the U.S. Patent and Trademark Office. This resource is especially helpful at the beginning of your business naming process—before you develop products, taglines, and services. If you find the name you want is already being used, it's possible that you can still use it, so long as what you do is strikingly different or is done under a different trade classification.

To search for trademarks, visit the website of the U.S. Patent and Trademark Office, www.uspto.gov.

In addition to visiting the U.S. Patent and Trademark Office website, I recommend doing a Google search on the business names you have in mind. See what already exists and who already exists with the same name. Is the existing concept very similar or quite different?

Check to see whether the website domain name is available, and search for variations. Also, avoid using hyphens (-) in your URL. The easier it is for people to remember you and your business name, the easier they'll find you online and in person.

As you learn more about your business and your audience, you will find that certain keywords and ideas stick with people. It will be to your advantage to understand how others perceive what you do before you marry yourself to a business name.

SETTING UP YOUR BUSINESS: GET A BOX

Whether you are starting your business from scratch, or you are reevaluating the way you stay organized in your current operation, maintaining a dedicated physical space for business-related activities is essential. Starting with a box—a literal box, or even a series of binders, can help you carve out space in your studio or home-office for important paperwork related to your business entity for the local, state, and federal government.

For key forms and files (i.e., a business license, business registration, federal ID number, etc.), having a reliable system in place will make your life easier because you'll always know where to find the forms and numbers you need.

Your physical business box could be a portable filing or storage container from an office supply store. Find one with a lid and a handle so you can relocate files with ease. Another option for storing physical files is using a three-ring binder with page protectors and section tabs. Or you may prefer a filing cabinet or another method for filing and storing physical documents.

Your digital business box could be a folder on your computer's desktop, an online cloud storage system, a back-up hard-drive, a set of jump-drives, or another digital storage method that supports your electronic storage needs.

I recommend using a hierarchical system to categorize files and stay organized. Mirror the same system structure in both your physical and digital organization.

Why is it necessary to have a two-part, physical and digital file storage system? Simply stated, two systems reduce risk. If your computer is stolen, but you're covered with a physical storage system, you'll still have access to important identifying numbers and documents safely stored in a secure place at home or in your office.

Similarly, if your physical documents are stolen or destroyed, you'll have access to backups online or on your computer. Healthy businesses are built on risk-aversion. Simple backup solutions make risk-aversion all the more possible.

What goes in your "box"?

Like the tools you use for your craft, everything has a place. When everything is in place, you can always find what you need. Items to include in your box are:

- *Your One-Page Business Plan*
- *Additional plans that support your business, like a marketing plan or revenue plan.*
- *IRS Forms & Information*
- *State-level Forms & Information*
- *Department of Commerce documents*
- *Department of Revenue documents*
- *City and County-level Forms & Information*
- *Business license(s)*
- *Register of Deeds documents*
- *Money Matters & Grants*
- *Business banking information*
- *Tax-related information*
- *Charitable giving (including donated artwork)*
- *Physical invoices/receivables*
- *Professional Agreements & Legal Contracts*
- *Professional services (CPA, attorney, etc.)*
- *Utility and space rental agreements*

USING AUTOPILOT SYSTEMS THAT DO THE WORK FOR YOU

In your craft and studio practices, you have likely found tools and shortcuts that reduce time, use material more efficiently, and ultimately, make your job easier. You may have a favorite tool you can always rely on to produce the high level of craftsmanship you want in your work, or you may have a set of tools that reduce manual labor hours and allow you to scale your work to create more with less.

Many artists in business prefer to spend time working on artwork rather than paperwork and accounting. I'm guessing that's true for you too. While administrative tasks are very important for keeping records, communications, inventory, and sales, they are not always the most fun aspects of operating a small business.

Learning about and setting up systems that save you time can make administrative tasks easier to manage. The trick is identifying the best set of business tools for your needs.

I encourage incorporating smartphone technology and the Internet into administrative tasks and communications as a number of low-cost, high-performance tools are available to small business owners. In fact, part of this book's purpose is to encourage the embrace of modern technology.

Next to a personal computer, a smartphone is one of the most powerful tools you can use for marketing, selling, and communicating in your creative business. A smartphone puts autopilot tools and systems in the palm of your hand, which means you are free to roam, my friend. Those dreams of travel and independence—all the while making artwork and money—are not only possible, they are happening for many creative people already.

The following tools and systems are recommended for artists who want to keep their businesses well-organized by automating administrative necessities. Many more tools are available—these are just the bread-and-butter basics.

Accounting & Bookkeeping Software

In business, accounting is essential. Quickbooks is a dependable accounting tool for creative solopreneurs and artists in business. Quicken is typically used for personal accounting whereas Quickbooks is a more robust business tool with options for managing inventory, sending invoices, and completing payroll.

For bookkeeping on the go, smartphone users can track receipts with a receipt-tracking app; there are many to choose from. This tool is helpful for keeping digital records and automatically tracking expenses.

Quickbooks (quickbooks.com) and Quicken (quicken.com) are products of Intuit, a leader in the accounting software industry.

Invoicing & Payroll Tools

If you sell your artwork or craft directly to a buyer, teach as a service in your studio or elsewhere, or receive payment for commissions in installments or in full, you may be in need of an invoicing solution.

As already mentioned, Quickbooks software comes with invoicing that balances accounts when payments are received. Another option is Freshbooks (freshbooks.com), an email invoicing program that you can access online.

Just as money comes into your accounts, it needs an exit route that gets you paid. Intuit Quickbooks offers a payroll option that takes care of the payroll taxes in your state and transfers your paycheck to your personal checking account for a nominal monthly fee. Another payroll option for yourself and your employees is Paychex (paychex.com), which offers a similar service. Both options are worth looking into if you want to outsource your payroll and tax collection tasks.

The leading companies for smartphone and tablet payment processing for small businesses include PayPal, Square, SalesVu, and Intuit GoPayment. Many banks now offer the same services too.

Remote Payment Processing Tools

First came the manual carbon copy credit card reader, which created an imprint of a buyer's credit card and receipt in one. Then, those with Internet or phone connections in their studios could plug in and run credit cards through wire. Now, using a smartphone or tablet and a credit card swipe attachment, you can automatically process payments from nearly anywhere. Transactions on the go make doing business from anywhere possible.

In choosing a remote payment processing option, find out:

- *Which credit card transaction fee structure is best for you.*

- *Whether there are monthly costs associated with the credit card processing system you want to use.*

- *When you can access processed payments— some companies will hold your money for 30 days if it exceeds a certain amount.*

- *Whether you can process payment for services as well as tangible products since many card processing companies prefer to work with retailers over service providers.*

DID YOU KNOW? According to the IRS, Standard Mileage Rates for 2013 were .565 cents per mile for business miles driven, and .14 cents for those related to nonprofit, volunteer, and charity work.

Mileage Trackers

Mileage Tracking is a must for anyone who drives to tradeshows, markets, conferences, and fairs to speak about or sell their work; delivers work to galleries, retailers, or buyers by car; travels to meet with clients, survey a site, or install work; or commutes to arts venues or school to teach, lecture, participate, or demonstrate. Basically, if you travel from Point A to Point B using a vehicle for anything related to your business, you will want to track your mileage. Mileage tracking is essential because "travel," as it relates to your business, can often be written off as a business expense.

Why is this information incredibly useful to as a small business owner? Knowing and tracking mileage informs you of the realities of operating your business. It also helps you determine where you may be able to reduce your expenses.

Mileage can be tracked manually by documenting your odometer readings and miles traveled in a pocket calendar or datebook. Or if you want a tool that does the work for you, download a "Mileage & Receipts Tracker" app to calculate mile expenses on your smartphone.

Your Website

Believe it or not, your website can do a lot of the work for you if you let it. Your website can tell visitors how to get in contact with you, when and where your work is available for sale and at what cost, what your commission process is, who you are, and what inspires your art.

> Want to see where people click when they visit your website? CrazyEgg.com can help with that.

Your website can set expectations, collect visitor statistics through *Google Analytics*, and give you visitor behavior stats through *heat mapping tools*. If you use *eCommerce* for sales, your website can even sell your artwork for you. For more detail on how to let your website work for you, see Chapters 9 & 10.

Email Address Databases

For artists in business, having an email address database means you have a direct connection to your fan base. As Jeffrey Rhors, author of *Audience: Marketing in the Age of Subscribers, Fans and Followers*, says, email subscriptions contribute to "Proprietary Audience Development." In other words, the opportunity to connect with and stay in touch with potential buyers and supporters of your work is invaluable. Your email contact database is a business asset.

With one of the many email marketing tools available to small businesses (e.g., MailChimp, Constant Contact, Aweber,

and Infusionsoft), you can let people know about your upcoming shows and exhibitions, share promotional opportunities they may want to take advantage of, and engage with customers through your brand.

To increase the number of contacts in your email database—and, therefore, your number of prospective buyers—add an email opt-in to your homepage or another well-trafficked section of your website. For more details on how to let email marketing work for you, see Chapter 9.

Customer Relationship Management (CRM) Tools

Business is based on relationships. In arts and crafts, relationships exist between artist and collector, maker and buyer, writer and reader, performer and audience, interviewer and interviewee, etc. Good relationships, partnerships, and collaborations are critical to success.

CRM tools are designed to help you maintain and manage the relationships that are important to your business. A CRM tool can help you stay on top of details, contacts, and opportunities. For CRM tool options and details, see Chapters 9 and 11.

Backing Up Important Documents & Files

Whether you are collaborating with other artists via the web, working from multiple computers, or are simply backing up files, a dedicated location for storing, sharing, and accessing documents keeps things simple. Think of the value in all the digital photos you have of your artwork—losing those photos could create unnecessary stress. Save yourself from this type of experience by backing up your computer's hard drive with at least one other method.

File storage and sharing options are a smart way to back up files and reduce the risk. Two free web-based options include *Dropbox* and *Google Drive.* You may also want to invest in a physical backup method like an external hard drive that you can take with you from studio, to office, to home.

Task & Project Management Tools

Whether you work independently or collaborate in teams, utilizing a project and task management tool will help you keep priorities and projects in order. Three web-based systems worth looking into are:

- *Basecamp (Basecamp.com), a task and project management dashboard for teams and individuals*
- *Wrike (Wrike.com), a solution for task and project management*
- *Trello (trello.com), a list and collaborative task management tool*

The goal of any support system for your business is to support it. Whatever tools you implement need to work for you rather than hinder your productivity. The best way to find out what works and what you really need is to test, test, test—and stick to what's best for you.

MAKING USE OF FREE PRODUCTS & RESOURCES

Google Apps for Business

If you are a fan of using Google products, you are in luck. Google provides free tools to complement independent and collaborative work. Google products for business include Gmail, Calendar, Drive, and Google+. All are easy to use with a free Gmail account, and all make use of cloud storage space to give users access to their email accounts, schedules, files, and networks from any computer or mobile device.

> You can sync your Gmail email account with your own unique domain to maintain your brand identity in your email (i.e., name@yourbrand.com) while using Gmail.

Free Telephone Number

Another Google product that is valuable to creative solopreneurs is *Google Voice*, which gives users a free telephone number that directs calls through an existing phone. Set up is straightforward—choose a phone number among the many available in your desired area code. Link the new number to your phone through the *Google Voice* app, and start receiving business calls without purchasing a new phone. This free option makes it easy to receive calls without giving a personal number to business-related contacts.

Social Media Marketing on Autopilot

Marketing your craft, skill, and artwork online is free and accessible to anyone with a computer, tablet, smartphone, and Internet connection. With free platforms like Facebook, Twitter, LinkedIn, Pinterest, Tumbler, YouTube, Google+, etc., you can build brand awareness, earn a fanbase, see what's happening in areas of interest, and market what you make. Hootsuite (hootsuite.com) is a tool that makes all of this possible in one location, and it even allows you to schedule posts, tweets, updates, and photos in advance.

Social media does have its costs—most of which include your time. While it is important to observe the social connectivity each platform possesses, using social media for business without some guidelines or intention can take time away from other important things. For more detail on using social media to engage with your audience, see Chapters 8, 9, and 10.

> If teaching online and eLearning are of interest to you, you may want to add online teaching to your own business offerings for additional revenue.

Professional Development & Training Opportunities

Yo-Yo Ma once said, "The great thing about being a musician is that you never stop learning." The same is true of being a business owner and an artist. It's never too late to learn something new, or refine what you already know.

Continuing your education and exploring opportunities to learn keeps you sharp. Most community colleges, small business centers, and chambers of commerce provide low-cost and free seminars to the public.

In some states, the Department of Revenue and the Department of Commerce give free workshops to business owners who are interested in learning more about collecting sales tax, filing quarterly returns, hiring employees, and other general practices in developing a business.

No matter where you live, access to the Internet means access to a fountain of information. eCourses and eLearning opportunities provide tutorials on most topics under the sun. YouTube is another quick and easy way to gain free training and information from others.

VIPS (VERY IMPORTANT PROFESSIONALS) FOR AN ARTIST'S BUSINESS

Doing everything solo has its challenges. Rely on your knowledge of your personal strengths and weaknesses to inform your decisions of when to bring in support for your business and delegate tasks.

CPA (Certified Public Accountant) or Accountant

Bookkeeping and tax filing are classic examples of tasks to outsource. If this is the case for you, find a partner who thrives on numbers and data entry. If you are on a budget or you want to work with an accounting specialist whose niche of expertise is in the arts, use Google to find the best accounting partner for your budget and needs.

A CPA can do more than just file your taxes and keep your books balanced. You may want a CPA's expertise to:

- *learn how to operate Quickbooks.*
- *understand sales & use tax in the state and counties you sell in.*
- *set up payroll for you and/or your employees.*
- *review and analyze profit & loss statements and balance sheets.*
- *inform you of tax deduction opportunities.*
- *discuss revenue targets to help you stay accountable to your financial goals.*

Looking to hire a CPA or accountant? Here are a few things to keep in mind:

Your CPA should be someone you trust. He or she has access to most of your personal information: Social Security number, business tax ID, addresses, earned income, debts, spending habits, etc. This person should be someone you can speak with openly and honestly. You want to be able to trust his or her judgment and advice.

A good CPA is forthcoming with information. He or she seeks to provide you with a basis of information for decision-making because he or she wants your business to be successful. When your CPA equips you with information, you have a better basis of understanding about your business and can make better decisions.

A good CPA provides you with an accurate snapshot of your business health while helping you plan for the future. Additionally, your CPA can help you navigate a tax year and save you money.

Trust, information sharing, and thoughtful planning are a formula for success with this important relationship. Finding

a fit that works for you is key. If you are looking, ask for CPA referrals from trusted sources, and interview a few CPAs to find someone you can jive with. Also, it's standard practice to ask for client references so don't hesitate to do so. It may save you headaches down the road to learn from a third party's experience with a CPA first.

Arts and/or Small Business Attorneys

Another professional resource to have in your back pocket, should you need one, is an attorney. Because attorneys specialize and practice in different areas of law, two types of attorneys that could benefit an artist in business are (1) a small business attorney and (2) an arts attorney.

Attorneys can help you understand contract language; set up your business structure; navigate licensing opportunities, copyrights, and trademarks; as well as settle disputes before they elevate. Chances are, you won't need an attorney any time soon, but it's always good to know where to find one.

Business Banking

I recommend separating business and personal money to make it easier to see your business as a business and yourself as a beneficiary of the business activity. It's also a simpler way of keeping up with accounts. Opening a business checking account creates a division between business and personal.

A business checking account should be free to open and use. Another option is to become a member of a credit union for business and personal banking. Credit union shareholders often receive better benefits and earned interest.

Your banker can also help you plan for the future by educating you on self-employment retirement options and setting up automatic annual contributions to your retirement fund.

Volunteer Lawyers for the Arts (www.vlany.org) has provided artists and arts organizations with legal aid, education, and advocacy for over thirty years. The online directory lists legal services for clients nationwide.

Use these websites to outsource tasks and find support: FancyHands.com, eLance.com, ODesk.com, and TempHelp.com.

Professional Peers

Anyone who thrives on stimulating conversation, values thoughtful and constructive feedback, and enjoys having a network of other creative professionals needs a group of peers in his or her field.

This type of group can be supportive professionally, and is likely to understand some of the artistic technicalities that friends and family may not.

OUTSOURCING ON A BUDGET

Being an artist doesn't mean you have to do everything on your own. Don't let such a thought limit you because we all have special gifts to share and no one can do everything solo.

A few other VIP roles that can aid your business include copywriting and copyediting, graphic design, website design and development, social media marketing, and public relations. If these activities are important but not in your strengths wheelhouse, bring in expertise to make them happen.

The benefits of outsourcing to help you get to the next level are usually worth the costs. If a rebranded look or updated website means you'll be able to sell your artwork at a higher price, it's worth investing in someone else's expertise to get the job done.

Within your network, you may find professionals or students to whom you can outsource work affordably. If you are on a budget, get creative in how you finance outsourcing. Bartering and trading can offset the costs of hiring. If your skills and offerings are equally as valuable to someone else as theirs are to you, you'll have yourself a win-win situation.

visualize

"Did you ever observe to whom the accidents happen? Chance favors only the prepared mind."

— Louis Pasteur

CREATING PREDICTABILITY IN A CREATIVE BUSINESS

What if it were possible to eliminate worry and inconsistency from your sales numbers because buyers, commissions, and other opportunities lined up at your door? What if you didn't feel guilt or self-doubt in taking a break from your creative work because you set boundaries that keep balance in work and play? What if you didn't work a sixty-hour week and, instead, enjoyed free time? What if your creativity truly worked for you?

While it may be difficult for some people to remove themselves from the studio, it is possible to structure your time so that existing work gets done and new work queues in the pipeline.

Artists who wear multiple hats in their businesses may at times feel overwhelmed, but not every hat must be worn.

To learn more about Jim Gallucci Studio, visit JimGallucciSculptor.com. And connect with the studio and Jo on social media at:

Facebook.com/ pages/Jim-Gallucci-Sculptor-Ltd/261018020506

Twitter.com/jaboykin

The two most important hats for the self-employed artist to wear are (1) the maker hat, and (2) the business development hat. One gets work done, and the other scouts work so there is work to do. When you focus on these two hats and let someone else handle administrative tasks, PR, graphic and website design, etc., your to-do list will shorten significantly.

Furthermore, once you have spent enough time seeking business opportunities through networking, PR, and great client referrals, you'll find that your business development scouting time decreases as well because opportunities are coming to you. By that time, it may be worth seeking assistants and part- or full-time employees.

Such is the case for nationally recognized sculptor Jim Gallucci. As Jim's right hand in business, Jo Boykin plays a big role. She handles business development, marketing, public relations, and more—all in one job title.

Because much hard work, time, energy, and money go into securing and manufacturing work for large-scale public art projects, Jim relies on a team of artists and assistants to bring business in the door and turn it around in a timely manner. I asked Jo to share a bit of her experience and role in prospecting for new business.

Heather: How would you describe your role at Jim Gallucci Studio?

Jo: My main job is to find and apply for jobs. I search for RFQs (request for quotes), generally decide if the work is appropriate for that call, and then put the required elements together to apply.

I also help run the office, work with clients, manage Jim's Facebook page and website updates, photograph most of the work and models for presentations, help put the presentations together—that kind of thing.

Heather: Would you equate your role to that of "business development" or the like?

Jo: I suppose business development applies since I do the majority of job [call] applications and actively search for the work. Jim has built a reputation and much work just walks in the door. But we have gotten jobs in places like Arizona and California that we might not have if I had not applied for them.

Heather: In general, how far into the future are you seeking opportunities to secure work for the studio?

Jo: As far into the future as possible! Some jobs will drag out for years, so you never know. We finally finished a job in St. Louis after three years. It was a job that was on the books, then the company dropped it, then it came back to life. You can't know when you'll have work or not, so you always have to chase it.

Heather: What methods do you use for prospecting opportunities, staying on top of things, and managing deadlines?

Jo: We're on several website lists that automatically send us public art opportunities. I stay on those constantly. I apply to jobs that Jim's work seems perfect for and for jobs that it doesn't seem right for. You just never know!

Jim manages the deadlines although I help him keep up with them. He manages the assistant sculptors so he knows when overtime is called for or when to drop one job to knock out another.

Heather: What advice would you share with artists working independently who want to pursue public art opportunities?

63

Jo: I would say that artists starting out will have to wear many hats. They will need to work for money in order to support themselves, spend their spare time applying for opportunities, and when they get them, they'll have to work those. I would advise finding a mentor, someone like Jim who has done this and been successful at it.

THE BENEFIT OF USING A PROCESS FOR PROSPECTING

Whether you are working for yourself or working in a team, using predictable processes within the business lets creative energy flow into your creative work rather than into business development.

In Jo's case, she uses a few different options for finding work that all fit within the same general prospecting process. A large part of a creative professional's job, particularly those entering a new market, is seeking opportunities that will become revenue for the business. Make your life easier by securing opportunities as far out into the future as you can. As Jo says, "You can't know when you'll have work or not." To secure opportunities, you need a sense of your business's seasonality and natural rhythms, along with a repeatable process.

Repeatable prospecting processes that could work for your business include: scouring call-to-artists websites and applying regularly; developing and maintaining relationships with those who appreciate your work enough to buy it, collect it, book it, sell it, and recommend it to others; listing your artwork and offerings on the Internet to make it easier for opportunities to find you; creating reasons for the press and media to get your name in print; securing funding, fans, and followers; and networking with those who may help you secure opportunities.

Prospecting for business implies that you know what you have to offer. This starts with your understanding of your internal offerings: what you do, make, sell, and share—all opportunities to add value. In most cases, you will either need to find a market for the product or service you've created, or you will need to create a product or service as the solution to a need or void you've observed in an existing market.

In the case of the former, many visual and performing artists create a product or offering prior to finding a market. Visual and performing artists often start with their individual craft, skill, and talent first, and they find a market for it second. For many commercial photographers and graphic designers, on the other hand, the latter scenario of matching a solution to a need is more likely because these creative professionals tend to create work with a client in mind.

Can both scenarios operate in tandem? Can an artist make art that is made without a buyer in mind, and also take assignments? Absolutely. In fact, having a variety of revenue streams adds security to one's cash flow and income. As the saying goes, you don't want to keep all of your eggs in one basket. At the same time, you don't want to have too many eggs in too many baskets because they may become difficult to manage.

TURNING YOUR OFFERINGS INTO VALUE

In Chapter 3, you wrote a short list of what you do, make, and share to add value to others. Develop that list further to give yourself a full portfolio of offerings.

Here's an example of a list of possible offerings a photographer may have:

- *Corporate headshots*
- *High school senior portraits*
- *Bridal photography*

65

- *Event photography*
- *Product photography*
- *Teaching photo lighting in-person, in print/ books, through digital downloads and e-courses*
- *Demonstrating techniques in-person, in print/books, through digital downloads and e-courses*
- *Mentoring new photographers*
- *Writing about photography and contributing expertise*

In the example above, each offering has the potential to be turned into a revenue stream for the photographer. The more opportunities the photographer has to add value to the marketplace, the greater the photographer's reach becomes.

Now it's your turn. Don't doubt yourself—you have plenty to offer that can add value to the lives of others. Keep it simple yet specific, and don't hold back.

Use the space below to brainstorm (or brain dump) your current and possible future offerings.

Current Offerings & Products

-
-
-
-
-
-
-
-

Possible Future Offerings & Products

- ░░░░░░░░░░░░░░░░░░░░░░░░░░░░░░░░░░░░░
-
- ░░░░░░░░░░░░░░░░░░░░░░░░░░░░░░░░░░░░░
-
- ░░░░░░░░░░░░░░░░░░░░░░░░░░░░░░░░░░░░░
-
- ░░░░░░░░░░░░░░░░░░░░░░░░░░░░░░░░░░░░░
-
- ░░░░░░░░░░░░░░░░░░░░░░░░░░░░░░░░░░░░░

In completing the exercise, you now have an extensive list of current and possible offerings that have the potential to add value to others and translate into revenue streams for your business. Next, categorize your offerings to see how each contributes to the whole for your business.

For each offering you've listed, place the letter "R" next to those that contribute most to the professional reputation you desire. Reputation-building offerings include things like sharing expertise through books, instructions, demos, and tutorials. Reputation-building offerings position you as an expert in your field. If the quality of your work and your style play a role in your brand, consider the offerings that relate to your aesthetic as a part of building your reputation too.

Other reputation-building offerings that have the potential to contribute to your overall income include teaching, speaking, and performing. People speak all over the world, every day at conferences and meetings. If public speaking is something you are comfortable with, consider it as a viable income stream with low overhead and high reputation-building potential.

> Speaking in front of groups about your artwork, techniques, and experiences increases your exposure and probability of receiving business referrals.

67

Next, place the letter "P" beside the offerings that can be created once, and sold or distributed multiple times, e.g., print editions, licensed artwork, video and podcast downloads, books, and ebooks. The letter "P" highlights offerings that can generate passive income for you.

Passive income—or residual income—implies that once the cost of producing the product is covered, you will earn a profit from the product whenever it sells thereafter. Passive income benefits creative businesses by adding to cash flow. To learn more about creating passive income using the Internet, see Chapter 10.

You may notice that several of your offerings are both reputation building and passive-income generating. Pay attention to these as you move forward in this chapter; they may help you to pare down your offerings and narrow your focus.

Finally, revisit each offering on your list, and indicate with a small heart shape the offerings you are most enthusiastic and passionate about. More than likely, these offerings prompted your desire to pursue your creative passions in the first place.

Having a list of everything you can do to add wonder and joy to others while generating an income for yourself gives you an endless supply of possibility. As you learn more about what you can offer your target market, add your new offering ideas to your list.

Identifying Your Top 3 Offerings

The next step in this process of identifying your offerings is to determine where you should start in order to make the most of your time, energy, and money. Even if you are already making money in business, use this process to reflect on what is working, what is not working, and use that information to help you prioritize your offerings.

In your offerings list, you are solving, creating, sharing, doing, teaching, and giving. All of these actions add richness to the marketplace, but they could overwhelm you if done all at once. Your energy is invaluable but not unlimited.

With that in mind, it's best to find a realistic set of offerings that you can build on to generate revenue and expand your professional reputation. Although you have a lot to offer, you really only need a few things to position yourself in your field, build a depth of knowledge in what you do, and make money.

Most modern day artists and creative professionals balance multiple streams of revenue to earn the income they need. The beauty of being self-employed is that your earnings have no limit. While it may be challenging to earn the income you need in the beginning, your experience, determination, and practicality will help you reach your financial goals.

To find your Top 3 Offerings, revisit your BHAGs to be reminded of your goals. Use these goals to filter through your list and determine your Top 3 Offerings. Write them down here.

> If you have seen a similar combination of offerings, that may be a good indication that all three are needed and valued in the market.

Top 3 OFFERINGS

1

2

3

Looking at your Top 3 Offerings, do they relate to one another? Is it possible for one to build on or contribute to the others, or do they all require separate and equal amounts of energy? Does one stand out to you—if so, why? Which of the three has the highest potential to make money for you? Which will be most rewarding?

DESIGNING YOUR BUSINESS MODEL BLUEPRINT

You've probably heard the term "business model" before, but have you ever wondered what it means? A business model is a foundational part of a business's plans, but it should not be confused with a business plan.

Think of a business model as you would the architectural layout of a kit home. In layout, the home looks nearly identical to that of its neighbors. But the customization of the exterior and interior, which can be compared to a business plan, reflects the style of the homeowners—or in our case, the business owners.

A business model gives you enough structure to be thoughtful and creative with everything else. It also directs how your business will turn offerings into revenue.

It's called a business "model" because it isn't entirely unique—models, templates, and plans can be used in many ways. Successful business models have been tested and used by others before.

What is unique, however, is what a business does once it has a business model. Applying their own style to the model, business owners create plans for bringing their customer experience to life, getting their product or service offerings to the right people, and keeping the lights on.

Why is it valuable to have a business model and a business plan? Having a business model means you have a natural flow of activity that directs your sales and turns your offerings into revenue streams. A business plan is where the creativity comes in; a plan adds your personal touch.

Use your Top 3 Offerings to determine how each fits—or doesn't fit—into the following business models. Keep in mind that it is normal to outgrow a business model when one's business evolves. Furthermore, it is possible to fuse the

> If you have observed that a mentor or peer has processes and systems in place, it doesn't hurt to incorporate some of that person's lessons learned into your business. He or she may have a business model that you can mold to your business.

elements of one model with another to encourage cash flow and keep your revenue even more predictable.

The following business model types can support the reputation, passive income, and passion categories you've identified.

Product Sales Model: Most fine artists, illustrators, photographers, product and jewelry designers, and craftspeople make physical products that can be touched and often need to be seen by a buyer before a purchase is made.

A product sales model can be divided into two sub-categories: wholesale and retail. When you wholesale products, you sell directly to retailers who will add their price or commission to your wholesale price before selling your work to their buyers. The benefit of using a wholesale model is that you have a guaranteed buyer for your work in your retailer or gallery partners—and they can connect your work with the public for you. Retailing, on the other hand, means that you are selling directly to buyers yourself.

Artists using a product sales model must do two very important things: make their artwork and get it seen. This process seems simple, but often, artists focus more on making than on getting their artwork seen. Depending on how you structure your productions and marketing, both can happen successfully.

Partnerships can be helpful for both creating artwork and getting it seen and sold. On the production side, interns, apprentices, and hired freelancers can provide support for prepping work and moving it from idea stage to finished piece.

On the "getting it seen" side, gallerists, retailers, and reps can be helpful sales partners because they make it a point to develop relationships with a buyer base. If these partnerships are important to your creative business, support them with what they need from you to be successful in selling your work, and be clear about what you need from them.

71

Other call to artists (CTA) sources include CallforEntry.com and ArtDeadline.com.

Another "getting it seen" option is to watch calls to artists (CTAs) and requests for proposal (RFPs) lists for opportunities that align with your goals. Most cities have programs designed to infuse art into the community, such as public art or Percent for Art programs. Visit the National Assembly of State Arts Agencies website to find a Percent for Arts program in your state, (NASAA-Arts.org/Research/Key-Topics/Public-Art/State-Percent-for-Art-Programs.php).

If all of your products depend on your physical energy, the ceiling for how much you can make and sell becomes fairly low. Using a product sales model that includes originals and editions, like prints, helps to balance the energy equation. You can generate cash flow through the sale of less expensive multiples, and develop originals as your more expensive offerings.

Another way to work around a scalability issue, particularly for the artist who doesn't want to offer multiples, is to raise the price of originals. Limited access—or perceived limited access—to something desirable creates natural demand. If originals cannot be replicated, their limited availability may command higher prices. Knowing this, you could sell your originals at a premium, particularly if you are known for what you make.

Digital Product Sales Model: Digital product sales models are often used by graphic designers and digital illustrators; web writers and website theme developers; musicians, singers, and actors who record; artists with video and digital technologies in their medium; and anyone who can share valuable information or teach digitally. Artists with digitized products can sell to customers directly via the web.

The digital product sales model can garner an enormous audience when marketed online. In such cases, artists using a digital product sales model will want to spend a large portion of their time building an audience and leveraging other people's audiences to get their products seen. Leveraging other people's audiences happens when you use eCommerce

platforms like Etsy and eBay for sales, or when you receive PR and interview features on other people's websites and shows.

Unless offerings are limited in quantity, a digital product sales model is a great way to scale up and sell more. They are usually intended to generate passive income because these products are created once and sold repeatedly. It is possible to market a physical product online, using a digital product sales model by building an online audience with whom you can share completed originals, and sell directly from your website or blog.

Information Sharing Model: Information sharing happens through in-person workshops, eCourses, books, online subscription magazines, video, podcasting, and instruction kits.

An information sharing model can benefit anyone with knowledge to share. If your strengths include teaching, instructing, consulting, and demonstrating, you can add value to the lives of others through education. With the assistance of a computer and the Internet, an information sharing model can easily pair with a digital sales model.

Brick and Mortar Model: A brick and mortar model lends itself to having a dedicated physical space to sell and promote one's offerings. This familiar concept creates a sense of permanency in the customer's mind. A physical space isn't likely to move and is a benefit to sellers who are committed to developing a local clientele.

While a brick and mortar model can be combined with any other model for increased visibility and sales, the downside to brick and mortar is the immediate overhead expenses that accompany leasing a space and up-fitting it for use. Another limitation is location—most brick and mortar spaces grow or fail to grow depending upon where they are planted.

One could, however, take a brick and mortar concept on the road with a traveling store in the form of an RV or truck. This could be a fun way for creative businesses to

73

For more advice on licensing, contract negotiations, and the like, reference these books:

Legal Guide for the Visual Artist, Fifth Edition by Tad Crawford 2010

Licensing Art & Design: A Professional's Guide to Licensing and Royalty Agreements, by Caryn R. Leland 1995

embrace creativity in entrepreneurship and work from anywhere. Location independence has its own set of rewards and challenges, but it provides flexibility for those seeking alternative work lifestyles.

Non-Profit Model: Most people confuse non-profit status with no profit. A number of non-profit organizations bring in a pretty penny every year, even if the organization's goal isn't profit for profit's sake.

While a non-profit model can be assisted by the tactics used in for-profit models, those interested in embracing a non-profit model should do as much homework as they can before proceeding. Joining the board of another non-profit is a good place to start. Reading books and learning about the realities of starting and advancing non-profits will help in the long run.

Licensing Model: A licensing model is like a wholesale spin on a digital product model. Licensers use the digital image of the artist's work for their own products, which are sold to the licenser's buyers. Sometimes licensers will pay the artist an up-front signing fee to create the design and pay royalties to the artist on anything that sells using the artist's design image.

Painters, illustrators, graphic designers, and photographers interested in licensing their work should do their homework to find credible licensers to work with. Navigating a licensing contract is best left to a trusted attorney.

Another avenue for licensing can be found in online stock image companies that connect your images with the general public. Notable online stock image companies include GettyImages.com, ShutterStock.com, and iStockPhoto.com.

Affiliate Sales Model: Affiliate sales and income models have existed for a long time, but they are often unknown to the buyer. Affiliate sales occur when a seller receives a

commission or a percentage for connecting a buyer to a sale. Perhaps the most common example of an affiliate sales model is real estate, in which real estate agents make a commission on the sale of a home or commercial property.

Ever since the Internet made it easy for people to buy and sell online, affiliate programs and sales opportunities have given people the chance to create partnerships to sell through affiliate sellers. The commission incentive works well for people who are great at creating online content (like posting to a blog weekly or daily), and developing an audience of dedicated readers who may benefit from affiliate products being promoted from the blog.

Visual and performing artists who share their passion through a blog or vlog (video blog) can make money as affiliates by forming partnerships with companies and individuals whose products they stand by and believe in. When artists who blog are informed of how a promoted product will help their readers, they can give honest testimonials to earn the sales commission.

Another way artists can leverage an affiliate sales model is by finding bloggers to sell and promote their artwork and creative services. By offering bloggers an affiliate commission on sales of the artist's offerings—particularly digital offerings—artists can enjoy sales support from the blogger's website.

Performance-Based Model: Performing artists, actors, musicians, singers, installation artists, dancers, spoken word poets, and the like tend to align their business activities with a performance-based model. For this type of model, two critical types of activities should direct the artist's energy: first and foremost, fine-tuning their skills, and second, seeking opportunities to share those skills with an audience.

> Want to find out whether your favorite products have an affiliate program you can take advantage of? Visit ShareASale.com to search for affiliate programs options, or browse the websites of products you use and would recommend.

These days, performance-based models have expanded to include speakers and those who broadcast their creative skills through outlets such as talk radio, podcasts, and video. In each case, audience development and fan engagement are critical. Remember: fans are earned, and their engagement with a performer's brand shouldn't be taken for granted. Performing artists who maintain their success understand this and strive to continue earning the attention of their audience with lavish gratitude. Think Elvis Presley's "Thank you, thank you very much," at the end of every song set.

Two valuable methods of building a fan base are:

- *Creating content that supports or is based on your craft and publishing it for your audience to enjoy. Publishing content can be done for free with the help of platforms such as YouTube and your website.*

- *Leveraging other people's audiences, like performance venues, performing arts and music fairs, organizations and institutions with dedicated performance spaces, and live or recorded shows.*

To leverage other people's audiences, artists will make the best use of their energy by identifying and building relationships with audience gatekeepers, or key holders—such as booking agents and program directors. Keeping those relationships rich for future bookings takes some of the business development prospecting out of the equation.

Public Art, Grants & Donations Model: Many contemporary fine artists, sculptors, installation artists, documentary film makers, special interest photographers, and social-commentary and environmental artists create conceptual work that isn't intended to be sold directly to a single buyer, but rather is created for the purpose of being shared with and experienced by a larger audience.

When this is the case, a public art, grants, and donations model can be employed to fund projects. There are foundations, endowments, and community programs that fundraise specifically for artists who are capable of executing a vision that requires funding support to make it happen.

Crowdfunding through platforms like Indiegogo.com, Kickstarter.com, GoFundMe.com, and Pubslush.com has made interest-based fundraising possible for the individual like never before. Such campaigns require as much, if not more, attention to a business plan if they are to be executed and run successfully, but they have the power to engage audiences and develop fans for the duration of the project or longer.

Membership Model: A membership model is similar to an information model in that it provides access to knowledge, workspace, tools, etc., that add value to the skills, business, and lives of others.

This model works well for artists interested in starting a cooperative or shared workspace with other creatives. It also supports those who want to provide a service that teaches the public through a pay-as-you-go structure.

Membership models are also helpful for those interested in sharing information through eClasses. In such cases, the combination of an Information Sharing model and a Digital Product Sales model could benefit artists looking to increase exposure and professional reputation while earning passive income on the sale of eCourses.

How do you find the business model that works best for you?

There is a lot of information out there, along with many options for supporting one's income. Here are a few tips for finding the best business model or business model combination for you:

- *Test, trial, and error. Never underestimate the value of trying something on for size to see whether it fits.*

- *Learn from your peers and mentors to observe what's already working in your industry.*

- *Look at other industries to learn from a new perspective; then apply what you learn to your own business.*

- *Experiment with combinations. Some models, like those that are performance–based, may benefit from having a finished product, like a CD, that can be used as a door opener for performance opportunities.*

Remember, the goal in using a business model is to give structure to how your business makes money and to provide you with the clarity and direction you need to be creative in making that happen.

SURVEYING THE SEASONALITY OF YOUR INDUSTRY

The good thing about every industry is that there's a natural rhythm specific to the industry's annual calendar. For some, business picks up around the holidays and slows down in the summer. For others, it's the exact opposite. Some depend on one key period, like tax season or the snowy winter for business. Your line of creative work has a seasonality too.

Holidays, cultural traditions, and the nuances that add familiarity to each calendar year affect supply and demand. When you understand what a typical year looks like for your

customer, you can play a role in that year. Most companies that create consumer goods have found Valentine's Day, Mother's Day, Father's Day, and the Christmas season to be the best sales periods. What are your best sales periods?

There's a seasonality in sales. There are months when sales are really good, and other months that are slow because demand isn't there. When you can predict the peaks and valleys in your sales, you can better plan for working hard, bringing in help, and taking time off.

What is the seasonality of your industry? When is the busy season? When is the slow season? (Assuming there is a slow season.)

Think about the key holidays and periods that affect your customers. Call on your sales experiences to determine busy and slow periods.

Within every creative field there are special events, awards, and conferences that occur annually. These annual events create deadlines, milestones, and flow.

Take, for example, documentary filmmaking; there are key dates each year for submitting films to film festivals. For many fine artists, annual grant deadlines and residencies are available at certain points in the year. There are also international fairs that could be important for research and networking. In fashion, designers participate in specific biannual shows to reveal their lines for the next season.

Use your knowledge of your industry to list the key annual events you definitely want to have on your calendar. Think about shows, festivals, conferences, and the like so you can plan ahead.

GETTING TO KNOW & LOVE YOUR NUMBERS

If you have listed accounting and money management as a weakness in the Strengths & Weaknesses exercise, your

desire to be in business for yourself should trump any fear of numbers you may have. The following section will help you embrace your numbers with open arms. As a business owner, knowing how much money is going in and out of your business will help you make better decisions and empower you.

It's exciting to make art and crafts, provide creative services that help others, and market one's offerings. Ultimately, the most important part of remaining in business has to do with numbers.

An intimate relationship with your numbers helps you to aim for consistency in monthly sales, save for a dreamy retirement, and keep things afloat.

An honest look at costs and expenses helps you eliminate excess and use resources creatively.

The thing about numbers is they never lie. Of course, human error and misinterpretation can skew things a bit, but 1+1 will always equal 2. Your numbers will always tell you whether or not your business is profitable, and they can help you plan ahead to secure showings and keep yourself booked.

Managing your business by the numbers helps you forecast and plan with confidence so you can spend your energy on the activities you enjoy and gain a desirable and encouraging return.

Estimating Annual/Monthly Costs & Expenses

Business-related expenses are a healthy part of a business's activities, yet many business owners skimp on the things that could help them in the long run, like updated software and marketing.

While it is important to spend wisely, bringing awareness to your business's essential needs and planning for important extras can help you creatively finance the things that will help you make more money.

Two types of expenses make up all business activities: product costs or *variable expenses,* and operational costs or *fixed expenses.* Estimating these expenses in advance can help you determine realistic pricing for your artwork and predict when you'll need to buy materials and supplies.

To estimate your current monthly and annual costs, take a look at what goes into the work you make—the final product. Use this information to create a list of variable expenses for your business.

This list may include materials, packaging costs that accompany your product, and labor costs if you use help or pay yourself hourly per product or project. Variable expenses may also include shipping.

My Variable Expense

variable expense	monthly cost	annual cost
TOTALS:		

81

In essence, variable expenses vary as the price for those things fluctuates. For example, if you find a cheaper supplier or decide to order materials in bulk, your costs may decrease. Or if certain materials are in high demand or the raw ingredients become harder to get, you could see your costs increase.

Next, let's look at your fixed expenses, which may include rent and overhead, utilities, phone and Internet bills, outside support (such as a CPA), marketing materials, insurance, memberships, loan payments, etc. Create a list of all the fixed expenses that help your business function, and estimate their monthly and annual cost to your business.

My Fixed Expenses

fixed expense	monthly cost	annual cost
TOTALS:		

I highly recommend using a tool like Quickbooks to enter all of your expenses as they happen. Paired with the GoPayment mobile swipe, Quickbooks can give you a snapshot of expenses over the course of a month, quarter, or year to help you forecast. Quickbooks also comes with a list of expense categories to help you itemize and track where money is exiting the business.

If you don't have Quickbooks and want to stay organized with expense categories using your own bookkeeping methods, here's a standard list you can reference:

- ☐ *Advertising*
- ☐ *Auto expenses (and mileage)*
- ☐ *Bank charges*
- ☐ *Copying/printing*
- ☐ *Delivery/shipping*
- ☐ *Dues & fees*
- ☐ *Continuing education*
- ☐ *Salaries & wages*
- ☐ *Equipment/computers*
- ☐ *Rentals*
- ☐ *Insurance*
- ☐ *Legal & professional fees*
- ☐ *Meals*
- ☐ *Memberships*
- ☐ *Office supplies*
- ☐ *Rent*
- ☐ *Internet*
- ☐ *Postage*
- ☐ *Publications*
- ☐ *Software*
- ☐ *Tax preparation*
- ☐ *Telephone*
- ☐ *Business travel*
- ☐ *Utilities*

When you know what your expenses are, you can find ways to offset and cover them. Expense information is empowering. You can always lean on the expertise of a trusted accountant, bookkeeper, or freelance CFO for support.

Creating Quarterly Quotas & Monthly Measurables

In many traditional corporate offices, sales employees are incentivized and rewarded for helping the company meet specific revenue goals. This motivational tactic can help you reach goals in your business too.

When you begin a month or a quarter with a numerical revenue goal in mind, your goal becomes measurable. At the end of the month or quarter, you can see how well you reached your goal, analyze your success, and decide how to improve next month. Along the way, you can track your progress and find creative ways to exceed your earnings, rewarding yourself for particularly good months. This method of measuring and incentivizing will help you predict your return on investment and maintain predictability.

ESTABLISHING PREDICTABLE BOUNDARIES

Never fear the power of directness. Sometimes your customers need to know they are operating within your structure of doing business. This is how you establish yourself as an expert to be trusted and valued rather than another set of technical skills to be used.

Be explicit about how you operate—you may be surprised by how willing people are to play by your rules. Let people know exactly how to commission your services and purchase artwork from you. Directness sets the tone for predictability and professionalism, and it separates you from hobbyists.

Boundaries also include informing prospective buyers when you are available and when you are out of commission. When people know they can't get what they want all of the time, and that they need to schedule you in advance, you may be able to command a waitlist—so long as what you make and do is worth the wait.

Boundaries can also create a sense of exclusivity and buyer urgency. If you set parameters for how many pieces you make each year, or when you are available for commission work and teaching, your availability becomes a premium that others must take advantage of—or miss out on.

Establishing Business Principles that Serve You & Your Buyers

A shortlist of business principles or guidelines can make difficult decisions easier, and ultimately create a framework for predictability in how certain scenarios are handled within your business. Whether your business principles are shared with others or kept to yourself, operating with them helps you maintain consistency.

Think of your business principles as a set of values that you honor within your business. In most cases, business principles support the underlying mission of your business, and they reflect your own personal goals.

Situations are bound to arise with customers, partners, and service providers. It's helpful to have a strategic plan that guides your business ethics for handling situations. Your business principles will help you deal with challenges that come up internally and externally.

One likely scenario you may face is deciding how to respond to requests for donated artwork. Artists are often targeted for donations of their art for charitable giving and auctions. This situation may present a conflict of interest to the artist and existing collectors if the artwork being donated is bought at drastically discounted auction prices, or if the cause doesn't align with the artist's values. How would you handle this request if it were made monthly?

Think about how you treat people and the values you uphold in your everyday life. You can apply your values to the relationships you make through your art and your business. What does the business-side of your creative work stand for? What does it not stand for? The groundwork for your business philosophy creates the foundation upon which your business stands.

Here are a few examples of principles you may want to incorporate into your business:

- *I will treat others as I would like to be treated.*
- *My collectors are my most valuable business partners.*
- *If I say I'm going to do something, I can be counted on to follow through.*
- *I will commit 100% to projects based on the joy and/or revenue they bring me.*
- *I will donate artworks to organizations that support _____.*
- *To honor the investment of my collectors, I will not donate or discount my work.*
- *Once my pricing is set, it can only increase— never decrease.*

Your Business Principles

Your turn. What are your guiding life and business principles?

My Business Principles

-
-
-
-
-
-
-
-
-

Next, we'll look at the power routine can have in one's business and life.

"It's vital to establish some rituals—automatic but decisive patterns of behavior—at the beginning of the creative process, when you are most at peril of turning back, chickening out, giving up, or going the wrong way."

— Twyla Tharp

DEVELOPING ROUTINE AS A CREATIVE SOLOPRENEUR

On an overcast, drizzly afternoon at the community craft center, a group of metals and jewelry students take their seats in the dimly lit classroom. The banter dies down as they prepare to view a slide presentation of the work and travels of their instructor, Amy Tavern.

From my vantage point by the window, it is clear the group has bonded quickly under Amy's instruction. After a two-day intensive course called "Innovating the Chain," they are comfortable with each other and eager to hear Amy's story.

To learn more about
Amy Tavern, visit
AmyTavern.com. And
connect with Amy on social
media:

Facebook.com/pages/
Amy-Tavern/17108092411

Twitter.com/AmyTavern

Instagram.com/AmyTavern

Pinterest.com/TavernAmy

Amy begins her presentation. She has given versions of this talk at other art and crafts locations as an instructor, visiting artist, or resident artist. Her slides are arranged chronologically—organized as a retrospective, grouping milestones in her career like bookends. She speaks about her work and methodology with an enthusiasm that her students tune into. Now privy to the intimate details of her creative process, Amy's listeners are no doubt reflecting on their own.

Her transformation from production jewelry designer to internationally recognized jewelry artist began four years earlier, in Penland, North Carolina, as Amy was nearing the end of her first year as a resident artist. Perhaps Amy's transformation began earlier with her decision to pursue an artist residency—a place and time of dedicated exploration for growth in an artist's journey.

The first year at Penland included nonstop activity in and outside Amy's studio: filling orders, giving talks, showing slides, teaching during Penland's seasonal sessions, meeting self-imposed deadlines along with those of others, networking, giving studio tours, and being involved in a countless number of happenings that took her out of her own time and into that of everyone else.

With so much activity surrounding her craft, Amy had little time between events to process and reflect on the work she was making or her growth as an artist. Finding herself in a place of energy burnout, she was no longer inspired or challenged by her work. Her idea flow was debilitated and parched. She was overwhelmed by self-imposed expectations that she should continue making new production pieces, but she felt unmotivated to do so.

A chapter in her creative career was coming to a close to make room for the next. But in order to transition fully, Amy would have to carve out a space to let that change happen. It may have been in her favor that the season was transitioning with her.

Winters in small North Carolina mountain towns can be isolating, but for an artist with studio space only a few yards from her apartment, it was the best place to draw inward and be still.

When we think of routine, we often think of the predictable events that occur daily and weekly. Rarely do we refer to the changes in the seasons as "routine," but seasonality, depending on where we are in the world, shifts our senses and creates rhythm. Routine is also a balance between work and play. Both invigorate and restore the spirit.

For a creative solopreneur, healthy habits that nurture the body and enrich the mind are essential. Good, habit-forming routines set you up for success. Routine helps you get into flow and creates predictability in how you receive energy, use energy, and generate momentum.

Routine is no stranger to Amy Tavern, though at the time, she was shifting into uncharted territory and her routine had to shift with her. Here's what Amy shares about routine as a catalyst for change in her essay, *"Part of the Process: One Year of a Jewelry Maker's Transformation"*:

> After my first anniversary as a resident artist, I began to define my creative process. I used these months to examine my work very closely through a selection of specific, self-motivated studio practices that revolved around thinking instead of making. This was a solitary time for me and it was absolutely wonderful.
>
> Every day I spent one hour on focused reading, writing, and thinking, dividing the time into four fifteen-minute increments. For the first quarter, I read from various books on mindfulness such as *Wherever You Go, There You Are* by Jon Kabat-Zinn. Next, I meditated, often concentrating on the sounds around me to clear my mind. Automatic writing—a

stream of consciousness style of prose—followed this, usually about my work or studio practice. I completed the cycle by reading a book about jewelry.

I felt incredibly good when I did this practice. It was a rich hour of my morning and helped set the tone for the day. Not only was I learning about my jewelry and myself as an artist, but I saw this practice and my other non-jewelry pursuits as a way to honor my work as well.

This daily routine was essential to Amy's transition. She needed to pause and process before proceeding. In a season of stillness, she gained what every creative solopreneur needs in order to create: self-awareness to guide process and clarity that is only found in a nurturing routine.

The lights came on and the slideshow finished. In listening to Amy's story, the students received a sense of comfort and pride in knowing that their own quirks and routines are important to their creative processes, so they should be honored and celebrated too.

This chapter, though strikingly different from those that precede and follow it, touches on a constant and critical element of preparation for all creatives: routine.

Twyla Tharp articulates the necessity of preparing for creative work in her book, *The Creative Habit: Learn It and Use It for Life*. She sets the tone for *anyone*—visual artists, performing artists, writers, business people—anyone, to recognize and establish behaviors that trigger action for getting into flow.

As an award-winning dancer and choreography superstar, Tharp has learned to harness routine for her creative productivity. When creative ideas and solutions are generated internally in the mind and fueled by energy from the body,

taking care of the internal should be at the top of the creative solopreneur's list of things to do.

To succeed in creative work, one's imagination, ability to create, and health must be nurtured—not taken for granted.

A HEALTHY MIND & BODY QUESTIONNAIRE

Narrowing in on imagination and health, give yourself a baseline for where you are presently in terms of taking care of your mind and body. Eliminating self-judgment and invoking awareness, respond to the following question prompts honestly with your current level of mind and body healthiness. Score as follows: 1 = never / 5 = often:

Mind:

Are there negative thoughts running through your mind about yourself or your work?

1 2 3 4 5

Do you compare yourself or your career to that of others?

1 2 3 4 5

Do you feel like you are giving to others without receiving support in return?

1 2 3 4 5

Are you having trouble making time for activities and people that give you joy?

1 2 3 4 5

Do you have trouble finishing things?

1 2 3 4 5

Is it difficult to choose a path, focus, or prioritize?

1 2 3 4 5

Does thinking about pricing your work or raising your prices turn your stomach?

1 2 3 4 5

Does speaking about your work or the thought of marketing turn you off?

1 2 3 4 5

Does selling feel uncomfortable, dishonest, or wrong?

1 2 3 4 5

Do you struggle with time management?

1 2 3 4 5

Body:

Do you spend time outdoors in natural daylight daily?

1 2 3 4 5

Are you able to engage in physical activity regularly?

1 2 3 4 5

Do you feel a balance between studio time and social time?

1 2 3 4 5

Do you give yourself your desired amount of vacation and time off?

1 2 3 4 5

Are you giving your body the nutrition it needs to generate positive energy for yourself?

<div align="center">

1 2 3 4 5

</div>

Do you get enough sleep each night?

<div align="center">

1 2 3 4 5

</div>

Are you experiencing physical stressors or aches on a regular basis?

<div align="center">

1 2 3 4 5

</div>

Are you happy with the type of work you are doing? Do you experience joy in your projects?

<div align="center">

1 2 3 4 5

</div>

Are you spending hours in one position, or using the same muscles to create your work?

<div align="center">

1 2 3 4 5

</div>

Do you take short breaks during the day or time off to recharge your energy?

<div align="center">

1 2 3 4 5

</div>

Aristotle touted, "We are what we repeatedly do." Often without knowing it, we create routines for ourselves because we are creatures of habit. But many of these routines aren't serving us.

Looking at your list, place a star next to any responses that don't jive with how you envision happiness in your life. You may not be making these parts of your life a priority. What can you do to change this? What does knowing that these routines are not supporting you mean?

Which of your responses could you improve first to set you up for success with the others? Chances are the first areas of improvement in your life will include the most basic of Maslow's hierarchy of needs. Physiological needs must be met before one can reach full self-awareness. Whether you consider it a curse or a luxury, human beings need to eat three times a day and get six to eight hours of sleep per night. Supporting your body and maintaining homeostasis makes it easier to achieve other goals.

TIME MANAGEMENT: INTENTIONAL VERSUS INCIDENTAL ROUTINES

Intentional and incidental routines create structure for how time is used.

Intentional routines are self-directed, like the habits we create without realizing it and those we assign ourselves for time management purposes. Intentional routines include scheduling a weekly check-in with an accountability partner; getting an annual physical; working for an hour before checking email, etc.

Incidental routines are a consequence of the things that happen in our direct environment—we create routine as a result of these events. Incidental routines include working in the studio between 9 a.m. and 5 p.m. because that's when the doors to the building are unlocked; starting your day at a certain time because you carpool to work with your spouse; working in the evenings and at night because that's when your kids are sleeping. Incidental routines depend on external factors.

Let's take, for example, a college student with a full course-load for the semester. Before the semester even begins, her calendar for the four to five months ahead is planned and contains structure. The structure begins on the first day class. It includes start and stop times for lectures, exams, quizzes,

breaks, presentations, field trips, assignments, projects, and papers for multiple classes that meet each week.

For the student, this incidental planning will keep her moving through the coursework at a steady pace, and though it is up to the student to embrace or reject this system, the system is in place.

Simultaneously, the student is naturally inquisitive and eager to learn on her own through social and experiential learning. She seeks out space and time to grow, be alone, explore, read, ponder, create, travel, and socialize with friends. These self-imposed activities occur with some frequency and intentionality.

Both structures help her plan, create momentum, maintain a healthy and productive lifestyle, and set her up for success.

There are natural starts and stops to daily rhythms. Working parents of young children may be some of the best managers of time. For the sake of their work and family responsibilities, they must find time to be intentionally present for both. And if their young children have schedules of their own, the incidental routines created by the school and extracurricular activities can dictate scheduling.

In working *with* time constraints, rather than working against them, you create a framework for productivity. Deadlines are the perfect example of leveraging time constraints in order to make progress.

Limitations foster creativity and deadlines help us get things done. If you were writing a book or painting a series of canvases without a deadline, would the work even get done? If time and options were unlimited and resources abundant, there would be little to motivate people.

Do you find momentum and agility in getting things done when you operate with structure and scheduling predictability?

What intentional and incidental routines provide structure and predictability in your agenda?

Establishing Routine for Getting into Flow

Getting into a flow, rhythm, or, as it is sometimes referred to, "getting in the zone," is important for anyone—but for a creative solopreneur it is absolutely critical. The "getting into flow" part of routine means you are more likely to make and do—to start something and see it through.

Even the most daunting of workdays can be pacified with a little familiarity. By integrating a pattern or series of small events into your start, you can train your mind and body to pick up where it left off and get into productive rhythm. This process looks different for everyone:

For writers, it may be drinking a cup of tea during a thirty-minute stream of consciousness writing exercise.

For illustrators, it may be settling into one's drawing table, turning on the lamp, and warming up the wrist with a few sketches in a notepad. Or it could take shape in the form of a mark making exercise with pen and paper.

For dancers, it may be gearing up and heading to the studio to begin a regimen of warm-up exercises that turn the muscles on and stimulate blood flow through physical movement.

For painters, it may be arriving in one's studio and turning on one's favorite choice of music to accompany color mixing for an hour.

For photographers, it may be using whatever environment you are in to capture as many angles of the same subject as you can in twenty minutes, then bringing that new perspective into your work.

Amy's practice of reading, writing, and thinking each morning helps her expand beyond her studio, into history and imagination. The combination of fifteen-minute exercises, albeit different exercises, creates predictability in Amy's daily routine.

Someone may spend thirty years in the same "getting into flow" routine. Think about how many people make reading the newspaper a part of their weekday or weekend routine.

What is your "getting into flow" routine?

Is this routine one that you employ daily?

How does your "getting into flow" routine support you?

Imagine an ideally productive day in which you are able to walk away from your working space feeling as though you've accomplished something and grown. How does that span of productivity begin? Describe it below.

Your Ideal "Getting Into Flow" Routine:

Creating Inspiring Workspaces

For many creatives, dedicated physical space for creative work isn't arbitrary or happenstance—it's essential to routine. Workspace environments stimulate productivity and direct energy. A studio space in which everything you need is in its proper place saves you time, particularly at the start of your process.

What role does workspace play in your work? Is location a critical part of what you make, do, or share? Do your location needs change depending on what you are doing?

What do you need in your physical environment to be successful?

Whenever Amy moves into a new residency space or temporary workspace, it's a part of her routine to unpack completely and set up her studio and life in her new location as soon as possible. This routine is her process for acclimating to her new environment.

When you find a workspace that inspires and motivates you, you know it. It could be that the ambient light is just enough to stimulate your senses. Or that the setup of the space lets you easily envision where your tasks and activities will take place.

You may prefer to be surrounded by your tools because the order in which they are laid out makes a difference. Or you may find inspiration in objects of meaning, such as photographs or keepsakes that bring you good energy. Maybe you thrive in a workspace with a large window overlooking a busy city that keeps pace with you.

Whether it can be explained or not, different places impact process and productivity differently. There's often an internal response to a place that tells you that you will be supported.

The elements you surround yourself with matter. Much like the practice of feng shui impacts the flow of energy in a home, a studio workspace contains energy that either works for you or works against you.

In the space below, map out a blueprint of your ideal workspace, including the activity areas that are a must for your work flow.

Need more convincing that time off is a good thing? Take a look at Stefan Sagmeister's TED Talk, "The Power of Time Off." (Ted.com/talks/ stefan_sagmeister_the_ power_of_time_off)

Next, list the objects of meaning you want to be surrounded by, along with the sensory elements (light level, sound and volume, textures, colors, etc.) that are contained within your ideal workspace.

-
-
-
-
-

Making Space for Serendipity & Time Off

When it comes to finding serendipity outside of your workspace, sometimes all it takes is being in the right place at the right time. Wire and jewelry artist Elizabeth Strugatz of WirednTwistednStoned.com is a serendipity magnet when it comes to sales. She finds that she sells her jewelry in the least likely of places simply by wearing it. Serendipity occurs in unpredictable ways, but being open to serendipity, i.e., putting yourself in the way of opportunity, makes it more plausible for serendipity to occur.

Giving yourself dedicated time off, away from your studio and away from your working environment, creates breaks in routine that can present opportunities not found in the studio. These breaks are especially important if you are a creative person who thrives on the new stimuli in your environment. Changing your environment changes your stimuli, creating a certain freshness to your approach and work.

When these opportunities are invaluable to your creative process, use them to your advantage. Give yourself a few mini-vacations throughout the year, and plan ahead so you can creatively fund them. Make travel a part of your business

development and your continued education by seeking workshops to teach or attend. You may also want to use time away for research and development, particularly if you are pursuing residencies or attending artist retreats that are geared toward improving your craft.

Understanding and Documenting Your Process

Understanding what you need to remain inspired can contribute to your understanding of your process. In my creative process, I've learned that six months without travel is stifling. My work becomes stale. I lose inspiration, and my pace slows significantly. This is because travel was a big part of my early development and continues to serve me in life. I have worked travel into my business plan in order to engage with artists and students and to learn new things. Even local travel helps me to be open to serendipity and increases my productivity.

Drawing on your knowledge of self from Chapter 2, what events, things, memories, people, and places inspire you? Does it add to your process to keep these things in your life?

Another method for understanding process is to document it while in the act of creating. For many artists, the act of documenting the art becomes a part of the art, if not the art itself. Amy Tavern has documented her work and life through a daily blog for many years. Her blog keeps her audience informed of what she is working on, where she is living, what she is experiencing, when she is teaching, etc. But more importantly, it provides Amy and her audience with a chronology of her evolution and experience as a professional artist.

In addition to blogging, Amy photographs inspiration. Her photographs are a part of her documentation process, but like her blog, they have become more—they have become her art. If you are thinking about starting a blog, follow Amy's for inspiration.

HONORING WHAT YOU NEED TO BE SUCCESSFUL

As an artist and solopreneur, it is vital to explore. What do you need in order to be successful?

Just as you develop an affinity for your medium and the tools that allow you to produce the look and quality you desire, exploring the places, relationships, and routines that either contribute to or hinder your success is imperative.

Invest in yourself. When businesses make money, part of that revenue is reinvested into the business to keep it sustainable. As the maker, producer, distributor, marketer, and vision for your work, what are you doing to reinvest in yourself?

Taking time off, enjoying family and friends, and traveling are all reinvestments that rejuvenate your energy. Taking classes, reading books, and attending conferences are reinvestments in your skill. Eating energy-rich foods, exercising, and meditating are reinvestments in your health. All are invaluable to your success and nurture your artistic self.

To learn more about Marissa Boisvert and move creative blocks out of your path, visit MarissaBoisvert.com.

Leaving Plenty of Space to Try and to Fail

Failing is an important and inevitable part of success. Only those who try and fail can learn from their trials and make improvements. Keep this wisdom in mind, and integrate a positive mentality around rejections and disappointments so you can leverage the process of learning and try again.

It is important to have a routine for dealing with rejection and disappointment. Marissa Boisvert, a behavior and change specialist who helps artists nourish their artistry through awareness, reminds us that, "Rejection is life's way of protecting and placing you right where you need to be." In dealing with rejection, go through the motions of feeling disappointment, but know that you are heading in the right direction.

Quarterly Resolutions

Anyone responsible for bringing in his or her own income needs a calendar system. A calendar is a critical component for planning, scheduling, and predicting activities for a given period of time. You may already be familiar with the saying, "Those who fail to plan, plan to fail." Use a calendar system to manage your time and reach your goals.

If you want to let your creativity work for you, plan out the non-business activities that are important to you and your family first, and work around them. Vacations, trips, and learning opportunities are worth setting aside time for. Your life should come first, and your business should support your life.

Large goals that require several months or years to achieve need realistic planning in order to come to fruition. Rather than narrowing your attention to just one large goal, break it into several steps that will inspire action and be easier to accomplish. Breaking large goals into actionable tasks and milestones directs intention and creates opportunities for you to see results.

I recommend focusing on three-month increments. What do you need to do in the next three months to get you closer to your goals for the year? People tend to make New Year's resolutions as a means of entering a new year with specific goals to change or improve their lives. How quickly do we forget to follow through on carrying out those resolutions?

By operating on a quarterly calendar and setting resolutions or intentions for each quarter, you'll have a condensed period of time to focus. A lot can happen in 90 days—you may surprise yourself.

Tracking Your Top Three Monthly Goals

In addition to making quarterly resolutions, use a monthly structure to support your intentions for the quarter. If you

> Take advantage of my Quarterly Resolutions & Monthly Goal Tracker downloads at my website HeatherAllenOnline.com/resources.

can do, delegate, start, or finish three things that will get you closer to your quarterly and annual goals, determine those three areas of focus at the beginning of each new month.

Because things that go out of sight naturally go out of mind, and because resolutions that aren't written down are often forgotten, write down your monthly goals. Visual reminders inspire action. Display your quarterly resolutions and your top three monthly goals in a location you frequent—like a bulletin board in your studio. If you prefer a digital reminder, set an electronic Post-It to your computer desktop. The goal is to stay on top of what's important.

Planning Ahead with the Help of Deadlines

By and large, one of the very best methods for making the most of time management is by instituting deadlines. Some people work very well under pressure and will wait until the last minute to complete a project, submit a grant application, or the like. But if that last minute never comes, it's possible that creative work will never get done.

Creative solopreneurs should fill their calendars with two types of deadlines: those that are self-assigned (intentional) and those that come from external assignment (incidental), such as client assignments, commission work, calls to artists, grant deadlines, lease start and stop dates, casting calls, dress rehearsals, etc.

If you need support in setting and meeting self-assigned goals, you may want to connect with other creative professionals for accountability—perhaps a monthly roundtable that meets to critique artwork or a business partnership that moves projects along. You may also want to seek more externally assigned deadlines that align with your annual goals and BHAGs.

Deadlines are a helpful way to stimulate productivity and get things done. Here are a few tips for meeting deadlines and staying in productive flow:

- *Make non-business activities—like family vacations and travel—a priority. Plan your calendar around key life events first.*

- *Always have things in the pipeline that you can look forward to.*

- *Surround yourself with people who are doing things and making things happen.*

- *Pursue and create opportunities that inspire you.*

- *Keep a list of projects and ideas you'd like to pursue.*

- *Keep your process rich with learning opportunities.*

- *Be rigorous in your work and enjoy the satisfaction of finishing things by rewarding yourself.*

- *Think about your audience and provide fans with opportunities to connect with you and purchase what you offer.*

- *Keep up the momentum with the help of a project management schedule that includes small milestones within each larger deadline.*

- *Manage your energy by producing and prepping work in batches.*

- *Do today what your future self will thank you for tomorrow.*

- *Find an accountability partner or create an art business support group.*

- *Announce a show date and location before you complete—or even start a body of work—just to challenge yourself and create a start and stop for your next series.*

107

YOUR PRE- & POST-SHOW CHECKLISTS

Another method for managing time and energy is to create checklists and set standards for the recurring activities in your business. Checklists are especially helpful once you've found your sweet spot for creating and promoting your work.

Take, for example, showing two- and three-dimensional artwork at markets or fairs. A lot goes into the planning, packing, shipping, showing, selling, post-show follow-up, marketing, communications, etc. If showing artwork at markets becomes a reliable source of sales and revenue for you, it might be one of your selling sweet spots. In that case, you'd want to make selling at markets and fairs a part of your business's recurring activity.

Rather than starting from scratch every time you gear up for a show, create a checklist to help you prepare before and after. Use this checklist method for all of your recurring activity to save you thinking time and energy so you can focus on what's most important to you during peak periods.

Here is an example pre- and post-show checklist for you to start with.

Pre-Show checklist
Pre-Show Marketing & Communications

- ☐ Send show invitation to email list 3 weeks before
- ☐ Follow up with invitation to attend show 1 week before
- ☐ Post show information on social media and blog
- ☐ Follow show on social media
- ☐ Connect with other artists/friends who will be at the show
- ☐ Follow up with the show organizer with questions you have

Artwork for show

- ☐ *15 large, framed pieces*
- ☐ *25 small, unframed pieces*
- ☐ *60 signed prints*

Display Options

- ☐ *Easel*
- ☐ *Table*
- ☐ *Tablecloth*
- ☐ *Lighting options*
- ☐ *Display books*
- ☐ *Picture frames*
- ☐ *Supply Packing List & Toolbox*
- ☐ *Pins & wires for hanging*
- ☐ *Hammer and nails*
- ☐ *Tape*
- ☐ *Scissors*
- ☐ *Needle and thread*

Marketing Materials

- ☐ *Business cards*
- ☐ *Rack cards*
- ☐ *Brochures*
- ☐ *Signs listing my name & studio*
- ☐ *Guest book to collect names & email addresses*

Sales

- ☐ *Price list*
- ☐ *Pricing tags for each piece*
- ☐ *Payment processing system*
- ☐ *Paper payment option*
- ☐ *Packaging materials*
- ☐ *Petty cash for change*

Extras

- ☐ *Water bottle*
- ☐ *Sunscreen for outdoor shows*
- ☐ *Pens & Pencils*
- ☐ *Directions to show*
- ☐ *Parking information*
- ☐ *Phone charger*
- ☐ *Camera & camera charger*

Post-Show checklist

Post-Show Marketing & Communications

- ☐ *Send thank you email to show attendees already on your mailing list*
- ☐ *Send a "nice to meet you" message to new email list contacts*
- ☐ *Upload photos and select the best to share on your blog*

- ☐ *Post about show on social media*
- ☐ *Follow post-show on social media*
- ☐ *Follow up with show organizer with a thank you card*
- ☐ *Follow up with new collectors with a thank you card*

Artwork for show

- ☐ *Update inventory*
- ☐ *Document what sold and what did not*
- ☐ *Display Options*

- ☐ *Return display options to their original home*
- ☐ *Wash tablecloth*

Supply Packing List & Toolbox

☐ *Double check that you still have everything you went to the show with*

☐ *Add any items you needed during show but didn't have*

Marketing Materials

☐ *Order marketing materials if supply is low*

☐ *Enter names & email addresses from guest book into email list database*

Sales

☐ *Record sales*
☐ *Confirm all processed payments*
☐ *Calculate sales vs. show costs to determine profit*

☐ _____
☐ _____
☐ _____
☐ _____
☐ _____

Extras

☐ *Do an "After Action Review" to document what worked well and what didn't*
☐ *Jot down notes from conversations with prospective collectors*

☐ _____
☐ _____
☐ _____
☐ _____
☐ _____

☐ _____
☐ _____
☐ _____
☐ _____
☐ _____

"There is no perfect fit when you're looking for the next big thing to do. You have to take opportunities and make an opportunity fit for you, rather than the other way around."

— Sheryl Sandberg

CHAPTER 6

POSITIONING YOURSELF IN THE MARKETPLACE AND CREATING LONG-TERM VALUE

Artists are the visionaries who bring stories, ideas, and imagination to life, all beginning with a seed in the artist's mind. Then, it is up to the artist to nurture that seed using the resources and physical energy he or she has, along with a good deal of faith that bringing the seed to life is absolutely necessary.

"Does the work mean something to you? Are you passionate about it? It needs to be your personal meaning for you, as opposed to what you think will sell." This is the advice gallerist Michael Foley shared with a group of eager artists,

To learn more about Michael Foley and Foley Gallery, visit FoleyGallery. com and TheExhibitionLab. org. And follow the gallery on social media:

Facebook.com/ pages/Foley- Gallery/134766791449

Twitter.com/foleygallery

both fresh and seasoned, but all with dreams of landing representation at a coveted New York City Gallery. He was kind, but direct with his advice.

Michael began his art career as an artist. Like many artists in search of their purpose and path, he looked for guidance and found it in another artist—his idol—who shared the advice that you must have a vision for life and depict that vision in your artwork.

As one who has worked in New York City galleries, including his own, for more than a decade, Michael has encountered much of what is worth seeing in the realm of photography and contemporary fine art.

When artwork is being shown to those who have seen a good deal of everything, i.e., gallerists in the New York City art scene, it needs to challenge its viewers to get their attention. That is the subtext of New York City art. It is what the New York City marketplace demands to get noticed in a sea of noise, clutter, great art, and over-stimulating hype.

As the presentation continued, pens and pencils feverishly recorded Michael's roadmap for gallery success.

He continued, "There are three things artists must have in their work: vision, identity, and style." These components are signature to an artist's work and brand. Most gallerists, like Michael Foley, seek that which can only come from the artist—this is part of building a brand that is recognizable.

Gallerists look for a level of artistic maturity and resolve in an artist's work to assess whether the artist will be producing work with the same zeal, vigor, and style in another five years. After all, it helps to build relationships with collectors when they know that the artist's work and style are consistent.

Michael went on to offer more points of gallery wisdom, such as when to contact a gallery, why it's important to bring dialogue into your pieces, and why each artist needs to

understand how his or her artwork relates to contemporary art as a whole.

His audience absorbed as much of his firsthand experience as possible in a ninety-minute presentation. The goal for many of the artists was to leave with clarity on how to connect with a gallery and reach the right market of buyers.

Michael lives in a place where the partnership between artist and gallerist still works. In New York, buyers and collectors spend mounds of cash on artwork. In the major spheres of art buying, a gallerist is a necessary broker, and the artist-gallerist relationship is mutually beneficial.

Selling art through the combination of gallery representation and direct sales from the artist works for some. Many galleries set specific boundaries for their artists in terms of where the artist can and cannot sell. There are pros and cons to this type of relationship.

Artists who have the option of selling directly to buyers on their own need the same relationship-building skills gallerists use with their buyer clients. Seeking out a market requires that you make yourself known and identify who responds. Then, cultivate those relationships for the long haul—bring them into your circle. There's a market for your work—seek it out and give interested buyers the chance to find you too.

Here's another story about diversifying your distribution. This one focuses on the world of art licensing—a major contrast to New York City gallery art sales in which every piece is one of a kind. In the art-licensing world, everything is a reproduction.

Several hours Northwest in Upstate New York, painter Andy Russell was curious about expanding his sales and getting his artwork out into the world. He had been approached by a company that offered to turn his artwork into puzzles, and he decided to pursue the offer.

To learn more about painter Andy Russell, visit AndyRussell.com. And connect with Andy on social media at Facebook. com/pages/Andy-Russell-Artwork/187985951242371.

This first licensing experience wasn't a huge success, but he did see some returns. After hearing about the Surtex Licensing Show in New York City, Andy decided to continue in the licensing direction.

To prepare for Surtex, Andy signed up for pre-show seminars to set his expectations. He created informational handouts about himself and mock-ups to give companies an idea of what the final product could look like (think calendars, coffee mugs, greeting cards).

His luck was in striking up conversations with those who approached his show booth. Andy's artwork was different enough to stand out—a key to getting people to stop and look. Some companies promised him the moon. Others offered to help him in other ways.

As a result of attending the licensing show and following up with the connections he made there, Andy secured several licensing rep relationships that took his artwork from the canvases in his studio, to a variety of print mediums circulating the globe.

Much like working with galleries, there are pros and cons to working with licensers too. But, if your goal is to secure distribution partnerships, learn as you go and stay focused on your goals. As Andy Russell says, "You have to believe in your work and be sincere about it. Put it out there and see what happens."

MARKETPLACE ECONOMICS

No matter what your artwork looks like, there is a market for it. No matter what you offer as a service or product, there is a need for it. No matter what you write, sing, or teach, there is an audience for your talent.

This combination of market need paired with everyone who can satisfy that need creates what is simply referred to as a "marketplace."

Marketplaces in any industry are rich with diversity in their consumers, their price points, and their offerings. Even the most outlandish products, services, and offerings have customers—people who either want or need what is being offered. Unless you intend to keep your creative work to yourself or are developing a need that has never been satisfied before, there is already a marketplace for your creative work and it is waiting for you.

Realizing that your creative work, though unique, still has a place within a market is a major advantage. Having a market means you can earn an income from sales to customers in your market. What better way to let your creativity work for you than by producing art that brings joy to you and to paying customers?

It used to be *faux pas* to discuss the commerciality of art because doing so would tarnish its purity and create a conflict of interest. But every artist asks the same questions: "How do I price my artwork?" "How do I attach a numerical figure to what I do, especially if it's something I love to do?" and "How do I position myself in a marketplace that is already filled with people doing similar things?"

All are valid questions that are terribly hard to answer without a sense of the market for which your offerings are a fit. In every marketplace, a pyramid-like structure exists in which the exclusive top is accessed by only a few, and the bottom creates a broad reach that is accessible to the masses.

Whether your offerings fit at the top, bottom, or somewhere in between often depends on how you package and position your offerings, and how willing you are to compete for the spot you want.

Within each pyramid are sub-pyramids. Take, for example, the music industry, which is comprised of mainstream genres such as pop, country, jazz, blues, etc. Within each of those categories is a myriad of subcategories that have their own unique histories, rhythms, and instruments.

Each subcategory also has a list of best-known names, including the founders of that genre and those who create the sounds of today.

This natural ecosystem of supply and demand (in a consumer-based economy) means that anyone can be a player, but only a few can "make it" to the very top. And even then, as trends come and go, those at the top must work hard to maintain their position and produce new, fresh, and inspiring works—or find a way to recycle what they already have in new packaging. This situation is true in any industry.

Stepping outside of the arts momentarily, let's take a look at a well-established marketplace that most people have access to and come into contact with: higher education. This marketplace has something for everyone because the need for higher education creates massive demand. Like other marketplaces, it has several levels. At each level, there are established schools that attract learners—or paying customers—who are eager to pay for education. The schools are providing these learners with a service offering.

At the very top of the pyramid are only a handful of colleges and universities. These schools succeed in attracting students despite charging some of the highest tuitions. Each year, hundreds of thousands of prospective candidates apply, a mere fraction of whom are accepted, filling classes to capacity. That there are only a few top schools, coupled with their costs and standards, contributes to their perceived inaccessibility, thus *continuing* the prestigious brand reputation that makes them who they are. In addition to earning an education, students are often aware of what makes one school's brand

different from another's. Students want to buy into the brand that matches what they value.

Simultaneously, community colleges offer an education that is far more affordable, providing everyone with an opportunity to continue his or her education. Community colleges have a broad reach; in fact, there are significantly more community colleges than there are top schools and Ivy Leagues. And every year, community colleges nationwide attract hundreds of thousands of applicants and fill classes too.

Both the perceived exclusive, elite schools and those that provide access to everyone serve and educate students every year. No matter where one's offerings are in the pyramid, there are customers ready to buy. The trick is to identify the customers who are the best fit for the product being sold at the price you want.

How does this example apply to what you do? Where do your offerings exist in the marketplace pyramid?

Before you can identify where you fit within the marketplace and who your best customers are, you need an understanding of what's already happening in your market environment. Here is where art history and music appreciation come in to play as they trace the origins and lineage of the creative arts.

MARKET RESEARCH

Most people see marketing as something one-sided—they only see the result of what happens behind the scenes, without realizing how much hard work goes into it. We usually only see the billboard, but we aren't privy to the number of focus groups, surveys, and demographic research studies required to make the billboard effective. These reference points are used to gather market research and inform advertisers whether or not to use the picture with the frog or the sheep in the next ad campaign.

Marketing is multi-dimensional. It blends a number of variables, including psychology, metrics, demographics, market and industry research, competitive analysis, sensory experiences, graphics, and a little bit of strategic planning.

So how can solopreneurs do market research without getting bogged down by all of the details? How does one stay in a place of creativity and understand one's field and competitive advantage? Great questions.

YOUR MARKETPLACE SNAPSHOT

The goal for the remainder of this chapter is to help you identify where your offerings can fit in the market. We'll focus on who the key players are in your field, where you should position yourself to be seen as one of those key players, and how to position your offerings accordingly. It's a tall order, so use the chapter exercises for guidance.

Once again, frame your mindset by revisiting your BHAGs, your business principles, and your Top 3 Offerings.

Depending on the customer for each of your Top 3 Offerings, you may have three overlapping markets to look at. For example, if you offer a service, a physical product, and a digital product, you may have different customer segments. Based on what you do, make, and share, it may be better to approach the exercises with one offering in mind at a time.

Start by identifying where you are in your market. To do this, look at the market as it exists without you. For fine artists, the brilliant thing about art history is that it's a living chronology of the who's who and the major influencers who have contributed to the family tree of art history genres. For those painting in a modern style, it helps to know who the modernists are and to see yourself as a part of their realm, even if they are no longer living.

The same applies to photography—look at fashion photography for example. The twentieth century was filled with iconic photographers. While only a few artists in your genre's history may have influenced your style, awareness of these references helps you to stay relevant and frames your marketplace within a historical context.

There are also living artists and professionals who are considered modern-day thought leaders in your field. They have reached national and sometimes global heights. Their name recognition and brand awareness is high because their work is referenced often.

Other people are just beginning to build their brand recognition because their careers are taking off. High brand awareness can take years to build, but it often results in higher pricing and more professional opportunities. If you see yourself building a brand that elevates your career, these thought leaders will be important for you to pay attention to, and if at all possible, connect with.

Next, there are competitors. These creative professionals and businesses cater to a similar audience as you do. They may even have a similar style, technique, and medium. They are considered to be competitors because they are competing for the attention of your customers along with you. Competitors are important to pay attention to because they can often tell you how to reach your customer more effectively than your own marketing can. When you interact with a competitor's brand and communications, you get to view his or her audience communications more objectively than your own.

Competitors can also help you see what options your customers are exposed to, and how you can make it easy for prospective customers to choose you for their business, fan loyalty, and their attention. The more you know about your competitors, the easier it becomes to differentiate and define yourself. Once you've defined yourself, you may find the competition coming to you for advice and collaboration.

Take a moment to list the influencers, thought leaders, and competitors in your industry.

INFLUENCERS, THOUGHT LEADERS, AND COMPETITORS

influencers	thought leaders	competitors

A competitive analysis can go much deeper and provide you with a wealth of information. If you conduct a strengths & weaknesses analysis of your competitors, you may find areas where your offerings shine in comparison. Take this one step further to find out pricing information, the amount of press attention each one has received, and any other points that would cause a customer to choose to work with another artist over you.

When you have a good sense of how artists within your marketplace compare to you in perceived value and brand recognition, you can better position your offerings. Market positioning may feel like a natural alignment with the artists you respect while allowing you to stand out with your own unique differentiators.

Perceived value happens in the mind of the customer when he or she tries to assess whether what is being sold is

worth the asking price. Generally speaking, perceived value is divided into low-end, medium, and high-end categories. One would expect the pricing of the offering to parallel its perceived value.

If the offering appears to be high-end, the customer will be willing to pay more for it. If it appears to be a low-end or average-quality product, the customer will expect to pay less.

SWOT ANALYSIS

Let's take market research further by completing the SWOT Analysis from Chapter 2. This time, we'll examine market opportunities and threats.

The SWOT Analysis is intentionally divided into two distinct parts. The first part, Strengths and Weaknesses, focuses on the internal talents of your creative enterprise. The second part, Opportunities and Threats, focuses on the external components found in the marketplace environment where your offerings are sold. The total SWOT analysis captures the landscape of your business.

It's likely that you've already identified opportunities for and threats to your business based on your interactions and observations in your field.

To see examples of *Marketplace Opportunities and Threats,* download the chapter worksheet at www.LetYourCreativity WorkForYou.com

PART 2: An External Baseline for Solopreneurs & Partners

opportunities (external)	threats (external)

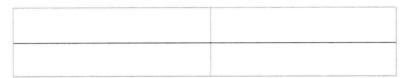

A SWOT analysis also reveals gaps in the market where a need isn't being satisfied. For example, if you live in a community with a medium-sized population with disposable income, and you notice that there are no arts-related classes for adults or children to be found, you could fill that gap by being the first to provide art lessons. This type of gap, as simple as it may appear, means that a potential need is yet to be satisfied. Your creative business could provide the solution.

In the list of opportunities and threats, you may have noticed that both opportunities and threats can exist simultaneously. Also, opportunities can become threats, and vice versa. In the list of examples, online artwork sales is listed as an industry opportunity that gives artists a broader customer base to sell to. It is also listed as a threat because buying artwork online may be commonplace because people also are buying knockoffs online. This threat may make it difficult to get the asking price you want—or it may challenge you to let your offerings stand out by commanding the price you want.

Complete the rest of the SWOT Analysis by revealing your external industry opportunities and threats. Then, use your list to capitalize on opportunities, and strike while the iron is hot. Also, stay in tune with threats that may affect your industry as a whole.

YOUR KEY DIFFERENTIATORS: WHAT MAKES YOU STAND OUT

When you know what is happening and who the key players are in your field, the only way to be counted among them is to stand out. Here are a few category-related questions to help you differentiate your offerings and sell yourself.

Service

Is there a need for the service offering you provide? Is anyone else providing it? Can anyone or anything substitute the need for your service? (Chances are your response is yes to all three questions—and it should be, unless you're coming up with something that people have no need for.)

Physical Product

Do you have something no one else has? Is your craftsmanship superior? Are you competing on materials and only using the best? Are you competing on price—is yours higher or lower than the average? Are there opportunities to introduce this product into new markets?

Digital Product

How do you make it easier for people to get what they are looking for in your digital offerings? How does your digital packaging and presentation compare to that of others? How do people find your digital offerings?

YOUR VALUE PROPOSITION IN 140 CHARACTERS

A snapshot of your overall marketplace, including its history and contemporary players, gives you a healthy understanding of the environment in which you play and sell. Because so few people take the time to analyze their marketplace landscape, doing so will give you a competitive advantage and give you a pulse on the opportunities and threats in your field.

Furthermore, knowledge of your marketplace helps you develop a niche for yourself, so you can become known for what you do.

- *What distinguishes your offerings from someone else's?*
- *What separates you from the crowd?*

Using Twitter's 140-character limit (including spaces and punctuation), describe your specialty and differentiators to your customers. This abbreviated value proposition can expand to become an integral part of your marketing and communications.

Here's an example to help you tailor your value proposition statement:

"My colors are bright and so are my collectors. I create tapestries that tell a story and unite cultures using the finest threads on earth."

My 140 Character Value Proposition

visualize

"The audience is the most revered member of the theater. Without an audience there is no theater."

— Viola Spolin

IDENTIFYING YOUR AUDIENCE AND UNDERSTANDING ITS DESIRES

Marketing I

No one understands audience better than the entertainment industry. People love keeping up with their favorite creatives in television, live performances, magazines, fashion, and the movies. But even the best performers know their fans aren't guaranteed to stick around forever. The attention of their fans must be earned, continuously.

Gordon Munro didn't reach celebrity status—it wasn't what he was aiming for, but many of his subjects were and most did. As a budding photographer in the 1960s, Gordon's hobby took him from apprenticing in England, where he was adept and skillful with his photo equipment and darkroom

To learn more about photographer Gordon Munro, visit GordonMunro.com.

processes, to New York City, where he turned his focus to a cast of inspiring subjects after apprenticing with the likes of Irving Penn.

Gordon worked for Penn for four years, learning as much about the industry as he could through the mentoring lens of one of the twentieth century's most prolific photographers. Then, with Penn's blessing, Gordon ventured out on his own to pursue his vision.

Over the course of Gordon's career, he secured commercial client contracts with Lancome, Revlon, Clinique, Saks Fifth Avenue, and Bloomingdale's. He landed print publication clients such as *Interview Magazine*, *Vogue*, and *Harper's Bazaar*. If you read *Time Magazine* in the mid-1980s, you may remember the cover photo of Shirley MacLaine at fifty throwing a stocking clad leg into the air. That photo was taken by Gordon Munro.

With the luck of being in the right place at the right time, Gordon attributes much of his success to the relationships he made in his career:

> Relationships are really important. I had good relationships with my clients. I had excellent relationships with the assistants who worked for me—we were all like family. If it weren't for those relationships, things would not have gone so smoothly. That reflects in your work, and can be detrimental for business.

Gordon's forty-year career in fashion advertising and celebrity photography put Gordon in front of big names like Alicia Keys, Ozzy Osbourne, and Elizabeth Taylor. Despite big name stars being in his studio daily, Gordon was working with real people with everyday needs and life desires.

Gordon came to understand what many of his subjects needed from him as the photographer—the person responsible for making the image happen.

Gordon also came to understand the needs of his publication clients—what they wanted and why they hired him for the job. As a result of Gordon's sensitivity to his clients' needs, he developed a reputation as a reliable professional with a signature style.

> My clients became friends, which made it much easier to work together to understand what it was they wanted. A photographer has got to psych out the client. You can't just shoot your way and expect it to service the client's needs. You've got to work closely with clients so that you understand what it is they want. In the same way, they come to you because they know what your style is and they know that style is appropriate for their project.

Gordon honed the soft skills required for working with people by listening to his clients' wants and needs. He delivered on what they wanted while staying true to his own artistic style.

Buyers, clients, collectors, critics, customers, evangelists, fans, followers, friends, funders, granters, readers, reviewers, reporters, subscribers, supporters, visitors. No matter what you call these people, they are a critical component of your creative business. They are your audience.

Your audience adds an engagement component to your art. Audience is essentially for turning monologue into dialogue. The individuals within your audience bring your art to life in their own way. Some by writing about it. Others, by buying it and living with it. Still others, by using it as inspiration for their own creative work. Whatever the case, these interactions are important to seek and pay attention to.

THE CONTROVERSIES OF MARKET PLACEMENT

While it is important to pay attention to how people interact with your work, finding one's marketplace audience—or letting it find you—is a relatively controversial topic. Why? Because strong opinions and feelings are involved in the argument of whether art should be made for art's sake without worry or concern of selling, or whether it should be made with a buyer in mind.

Both arguments are valid, and both approaches can turn into a viable vocation. Another reality to address is that no matter what you make, your art and offerings will have an audience, but not everyone will be considered a member of that audience.

Assuming that your art is for everyone casts a wide net with high expectations and large holes. Unless you're selling eggs, milk, and bread, what you make is not for everyone—and even then you'll lose people to food allergies. While it is highly unlikely that everyone will be a self-selecting member of your audience, it is possible that a large portion of your audience will at some point become collectors of your work.

Narrowing your focus to a specific group of people helps you understand the needs and desires of a targeted audience. The more familiar you are with a niche audience, the more efficient you'll be in reaching its members. For example, if you make large-scale pieces, your buying audience will likely be those with large spaces to fill. From there, you may find that your large-scale pieces fit in specific types of large spaces better than others.

Most sellers have to earn the buy-in of their prospective buyer before the offering can sell. Customers have to understand your offering in the context of their own lives before they decide whether or not your art is a good fit for them. This decision can take a few weeks, or a few minutes. When reputation, brand awareness, and relevance to the buyer are high, selling one's work becomes easier.

Think about your own buying behavior. You buy a number of things without thinking twice: food for your meals and gas for your vehicle are mundane, everyday needs you may purchase multiple times each week.

Then there are your impulse purchases—those products and services you don't necessarily plan to purchase but when the opportunity to do so presents itself, the buying process is so easy it's hard to say, "No."

And then there are the things you aspire to purchase. Here is where you want to position your work in the buyer's mind. Honest, unadulterated creative work, paired with a noteworthy artistic reputation, sets the stage for aspirational buying behavior.

Your ideal customer has similar buying tendencies. It's up to you to be there at the right time and in the right place to let the customer's buying decision be one that includes you. You want his or her experience with you to be one that is positive and rewarding so he or she buys again and tells others about you. Your job is to understand your customers' interests, needs, and desires in a way that positions your offerings as a solution, welcomed indulgence, and contributing joy in their lives.

FOUR KEY INGREDIENTS TO A GREAT CUSTOMER OFFER

How does one sell efficiently without being "salesy"? Remember: customers have to understand your offerings in the context of their own lives before deciding whether or not what you offer is a good fit for them. To make this happen more efficiently, use these "Four Key Ingredients to a Great Customer Offer":

1. *Know your target audience and its pain points, needs, wants, and desires.*

2. *Align your offer as the solution for your audience's pain points, needs, wants, and desires.*

3. *Educate your prospects on the value of your offer—especially if other people are offering something similar.*

4. *Make sure your customer can find what you are offering.*

When your offerings are positioned this way, your prospective customers won't feel they are being sold to. Instead, they'll feel they are making a decision with the information they need.

You can take this sales process further by sprinkling in some reputation boosting magic in the form of PR. By doing so, more people will find you more often through someone else's accolade of you. Sometimes, someone else's referral will sell you better than you sell yourself.

GETTING CLEAR ON WHO YOUR AUDIENCE IS

In his book, *Audience: Marketing in the Age of Subscribers, Fans and Followers*, Jeffrey K. Rohrs tells readers that with any brand or offering, "You—the customer—determine whether or not to become a part of any audience.... Your attention, action, and loyalty have to be earned by all of those who want it."

Who makes up your audience? Chances are, your audience is as varied as the colors in a crayon box. Their interest in you, your art, and what you have to offer are what attract them to you.

You are likely to interact with different types of buyer personalities. To make it easier to understand who your audience is, think of your customers as members of a few different buying segments. Then, address each segment as if you are speaking to one person. Let's call these segments "customer personas" to aid in telling the difference between one buying personality and another.

Finding Your Ideal Customers

The better you know your customers, the easier it is to market and sell to the right people. After all, you are selling to real people—a point I stress because an inherent difference between a business and a hobby is that a business has customers.

Knowing who your customer is saves you time. It gives you a glimpse into where your customer hangs out, thereby making it easier to show up there. It also helps you to narrow your focus when looking for new customers. There are billions of people in the world, but unless you're Google, only a small fraction of those people will need your offerings. It's better to narrow your target and identify your audience as you interact with prospects and buyers.

Customer demographics typically account for information such as age, gender, ethnicity, income level, whether or not a person is married or has children, etc. Demographics help us to understand where our customers are in their lives and what is important to them at this moment in time.

Attributes such as obstacles, challenges, and fears are commonly referred to as "pain points," but they can be as simple as trying to save money.

If you know that a segment of your customer base wants to feel as though it is getting a good deal on a purchase, you can cater to those customers' needs by encouraging them to see their purchase as an investment, thereby soothing their pain points.

Along with pain points, it helps to have a pulse on your customers' needs, wants, and desires. Ultimately, you will want to provide the solution for your prospective customers' pain points and the fix for their needs, wants, and desires.

Download the *Customer Personas Snapshot* worksheet at www.LetYourCreativity WorkForYou.com

Customer Personas Snapshot Exercise

Use this exercise to understand your customer persona segments and general demographics. View the sample list of five customer personality types to spark your memory of the customer personalities you've had interactions with.

Next, pull from your experiences with customer personalities. Maybe your customers are students who want to learn your techniques and have specific needs. Maybe they are buyers gifting your art to loved ones, or they are new homeowners who want to fill their homes with original artwork.

Think about what you know of your customers' demographic details. What needs and wants do they have? Where are they likely to find your art?

You may decide that the best way to address customers' needs is by showing them how your offerings align with their needs through photography on your website.

Your responses to "where they'll find you" should help you determine where and how to market to each segment—your offerings should show up where your customer is. Knowing this will assist your PR and marketing efforts.

Getting to know your customers comes with time and experience. However, by attempting to understand your customers and predict their needs and motivators, you'll be better able to position your offerings in the marketplace and create long-term value.

Observing Customer Lifestyles & Buying Behaviors

Many people are turned off by sales. Some even dread engaging in the selling process—particularly when they are selling their own art. This could, in part, be due to a commonly accepted association of sales with sleazy salesmanship. Most people don't want to be perceived as the pushy car dealer or the slick insurance salesman.

Luckily, the process of selling only comes down to two skills: listening and observing. These skills are of particular use to introverts and those who want to promote without appearing to brag. Spend your time listening and observing buying behaviors of your customers, and less time worrying about selling. Use the information you gather from listening to their needs to aid your sales, marketing, and communications. A lot of psychology goes into purchasing decisions and buying behaviors, and yet, a good ear and helpful demeanor is often all you need.

In addition to leveraging your listening and observational skills to understand your audience better, you will also pick up on when and how people engage with your art using the same level of awareness.

Returning to the section in Chapter 4 about your industry's seasonality, we know that buying patterns come in waves. Use your observations of your buyer's behavior in tandem with your industry's seasonality to prepare yourself for being where your customer can find you when he or she is ready to buy.

Want to understand the psychology behind buying and selling? Read Daniel Pink's book, *To Sell Is Human*, in which Pink shares nearly forty exercises designed to uncover the buyer's perspective.

> Remember, it's no longer who you know— it's who knows you.

GETTING TO KNOW KEY HOLDERS & GIVING BEFORE GAINING

Buyers who are in the market for specific things will often turn to their network for referrals and recommendations. Say, for example, that you are looking for a medical specialist. The first thing you are likely to do is ask within your network of friends and family for their specialist referrals. You may also consult Google for a specialist in your area, and you may read the Google reviews for the specialists you find while searching. Chances are, within those two very powerful search options, you'll find what you are looking for.

People tend to go with the recommendations of those they trust. Knowing this, if you want to be most successful in your creative business, focus on building relationships with the people your customer trusts since they will have the most influence on your customer.

Focus on bringing these relationships into your sphere of influence. After all, they have access to your customer audience in some form or fashion. Essentially, they are key holders who can open the door for you to new customers and new opportunities. These people are very important and very helpful because they can put you and your work in a room full of your ideal customers. Think of key holders as those with the ability to connect you and your ideal buyers. The one thing they have that you are striving to gain is that customer's trust.

Often, the best key holders to develop relationships with are those with influence. Influence comes in many forms, but three to pay attention to are: referrers, leaders, and the media. Referrers are going to be the people who recommend your work to others. Leaders are those whose opinions are valued in groups and in the community. And the media can be anyone who can amplify your news and your story—think reporters, bloggers, and writers.

Key holders exist within every industry and in every business. To help you think about who these people are in your business, skim the list of arts-related key holders in the *Getting to Know Key Holders* worksheet.

Much like in the customer personas exercise, these descriptions can be used as examples for identifying key holders within your sphere of influence.

The best way to gain a referral or leg up from key holders is by offering a hand first. If your key holders have pain points, needs, or wants for which you can provide a solution, find out how you can add value in their lives and workweek. Chances are, they'll experience your professionalism firsthand and will want to share your name with others.

Download the *Getting to Know Key Holders* worksheet at www.LetYourCreativity WorkForYou.com

Whoever you've listed as key holders in your world, it is just as valuable to get to know them as it is to get to know your customers. These relationships can pay off, creating triple wins for you, your key holder connection, and your customers. By engaging with your community, industry, and network, you may be surprised by how many key holder relationships you can acquire.

Inviting Press & Media into Your Inner Circle

People often forget that press and media professionals have to find enough material and stories to supply the demand for up-to-date news. Local media outlets need news daily, even hourly. Because of the rate that information is churned out into "news" through digital and physical media outlets, there is always a place for your news and story to be covered. The trick is to find out what the media needs and then offer your story as the solution.

One of the best resources available to people looking for press coverage outside of their geographic areas is HARO. com, a nickname acronym for "Help a Reporter Out." This resource is a reporter's best friend because it helps to crowdsource stories that match his or her query posts.

Subscribing to HARO will fill your email inbox with opportunities to get your story picked up, and like an application process for a juried show, the more queries you respond to, the higher your chances are of earning press coverage.

On the local level, reporters and writers are hungry for content to share with local readers. If you read the local paper and frequent local publications, you're apt to find calls and solicitations for content. These are opportunities to tie in a story that is both relevant to the general public and in some way showcases you. If writing is among your strong suits, you can offer to submit articles as a contributor and secure features that way.

Blogger communities are another growing media outlet opportunity as Internet marketing and online businesses expand. Bloggers write about every topic under the sun. To secure coverage and interviews with bloggers, dedicate time to researching and engaging with those who have covered stories and artwork like yours in the past, or who have an overlap in reader interest with your interests. Research is a prerequisite for gaining blog coverage.

Bloggers who post regularly and maintain a large, dedicated readership are looking for interesting things to share with their readers. Your chances of securing an interview with a blogger increase when you engage with him or her before looking for coverage first. Perhaps you could offer a giveaway or a few tips that the blogger's readers could benefit from reading. This tactic becomes a triple-win for you, the blogger, and his or her readers.

CREATING YOUR PRESS KIT + ASSETS

Those who track down stories to share with their audiences for a living often have a lot to juggle as news stories develop. Surely, if your story is a good fit for a blogger, reporter, or writer, that person will appreciate your assistance in getting the story covered accurately.

The best method for providing press and media personnel with the information they need is through a digital press kit on the press page of your website or in a sharable Dropbox (www.dropbox.com) file folder. If press coverage is what you are after, treat the press and media as a special customer segment by understanding their needs before you need them. A press kit should include:

- ☐ *Your biography.*
- ☐ *Your artist statement or a similar message that supports your artwork.*
- ☐ *High-resolution photos (300 dpi) of you and your work—photos and videos are referred to as assets.*
- ☐ *High-resolution product photography if you sell merchandise.*
- ☐ *Links to your videos.*
- ☐ *Links to your past interviews.*
- ☐ *Your contact information and social media links.*
- ☐ *A press release for your upcoming news.*
- ☐ *Quotes from you that can be used in an article.*

WHEN, WHERE, AND HOW TO USE A PRESS RELEASE

A press release is a write up that shares news and updates with the press in an organized, detailed, yet concise way. Press releases are typically no more than a page—you can find examples in a simple Google search. Most press releases

contain the "who, what, where, when, why, and how" of the matter being shared, including dates, times, and locations.

An artist can use a press release to announce show openings and closings, share a bigger message that goes beyond the artist's work and affects the community, share personal interest pieces, promote events, and connect relevant news with a variety of readers.

Keeping your name in the press keeps your name in the minds of prospective fans, customers, collectors, and buyers, ultimately elevating your professional brand and career.

When people use a press release to share their news with the press, they are inviting a third party to connect their news with different audiences in whatever way the third party chooses. But when you have relationships with press professionals, you are more likely to get your news covered in a way that presents it in the best light.

Most press professionals prefer to receive a press release by email, so they tend to make their professional email address available in their articles and company website. When you plan ahead with a public relations strategy that includes social media, you will find that your news travels farther.

Depending on your goals and budget, it may be worthwhile to hire a freelance publicist for your project or a PR firm to elevate your brand awareness and secure press coverage for you.

CULTIVATING CUSTOMERS INTO LOYAL FANS

Never take for granted the relationships you have with those who purchase your artwork. Relationships are the single most important part of any and all business—they are what give the business-side a soul. When you develop close rapport with your buyers, you may find their investment in you and your art to be more than monetary.

Cultivating loyal, raving fans happens when we are thoughtful and intentional in our customer's experience process. Much like welcoming guests to your home or hosting a party, your customer experience process can be filled with opportunities to make your customer feel special—and feel like he or she is among a select few who get the privilege of knowing an artist. This recipe can be used in person—such as during a studio visit. And online, through email marketing communications, social media engagement, and even in the language you use to guide people through your eCommerce checkout.

View your sales and opportunities as a part of a continuous relationship, as opposed to a one-time occurrence. You can tell the difference between the seller who sees your purchase as a "one and done," versus the seller who sees your purchase as the first of many. The former is ready to take your money and be done with it. The latter is more apt to spend time helping you choose the best fit for you, and he or she becomes a resource after the transaction.

Which type of seller do you want to be? From an energy perspective, it's much easier and more rewarding to develop real relationships with real collectors and buyers than it is to search for new sales leads constantly. Collector relationships are especially important for artists who want to increase their fan base and sell directly to buyers, as opposed to using a third party—like a gallery—for the majority of their sales.

Collectors are called collectors because they collect your work, which implies that they buy from you multiple times. As stated in the introduction chapter, the modern day artist has the power to redefine what it means to be an art collector and inspire "collector mentality" in any unassuming fan. Some people just need to know they can become a collector as the thought may not have occurred to them.

ANSWERING CUSTOMER QUESTIONS WITH A FAQ & SAQ LIST

How many times do you hear the same questions being asked about your life as an artist, and how you do what you do? You are likely to hear certain questions more times than others.

- *How long does it take you to finish a piece?*
- *When can I expect to receive a piece that I purchase from your website?*
- *Is shipping included in the final price?*
- *Can I request specific colors or do you only have available what is in stock?*

Let's say someone has a question about your work or your offerings, but you're not there to answer it in person. Chances are the person will go to your website. To make sure people find the answers they are looking for, address customer questions through your written copy—the written text on your pages. You can also think of copy as any verbiage used in a video. Images can address customer questions too, and save you a lot of copy writing.

Or you may want to consolidate questions and answers in a FAQ page—a list of frequently asked questions and your responses. You also should add to this list any SAQ—should ask questions—these are the questions your customer may not know to ask.

The benefit to having this level of preparation and question anticipation is that it saves both you and your prospective customer time. Think of all the email communications you won't have to send if your prospect finds what he or she is looking for on your website and can proceed without a purchasing conversation with you.

Answering questions up front gives your prospective customers the information they need to make good buying decisions. It also helps if you keep a running list of customer

needs so your customers will have a better buying experience with you. They will see that you are detail-oriented and care.

Furthermore, providing your prospective customers with information educates them on the value of your offering, which is one of the *Four Key Ingredients to a Great Customer Offer*, discussed earlier in the chapter. If most or all of your customer's questions are answered in advance of making a purchase, the only question left to be asked is, "Cash or credit?"

Reflect on your customer interactions and the experiences you have had with buyers. Then, come up with a list of Frequently Asked Questions and Should Ask Questions along with your responses. As your customer interactions supply you with more questions to be answered, add to your list.

USING GOOGLE ANALYTICS TO LEARN MORE ABOUT YOUR CUSTOMERS

For anyone who (a) uses the Internet for business, (b) uses a website as a primary tool for marketing, or (c) sells directly online, Google Analytics (www.google.com/analytics) is your best online business advisor.

Google Analytics is a free tool that provides website owners with important website visitor data. This tool is particularly helpful for those doing business online because the data points can provide customer demographics, the search terms people use to find your website, and much more. As the name suggests, Google Analytics analyzes the viewer traffic—valuable information that can be used to gain more website views.

Want to learn more about Google Analytics? Visit the Google Analytics Academy online for free tutorials at www.AnalyticsAcademy.withGoogle.com/.

If you draw portraits in charcoal, use Google's keyword planner to compare the amount of searches conducted for the phrase "charcoal portraiture" versus the phrase "charcoal portraits." Verbiage research helps to determine which terms yield the most results and which terms should be included on your website.

USING SEARCH TOOLS TO LEARN WHAT YOUR CUSTOMER IS SEARCHING FOR

Search term websites can help you understand what your customer is searching for, and those search terms can give you loads of ideas for what to blog about next. A few bookmarks are:

- *Adwords.google.com/keywordplanner—As Google's search tools evolve, they become more robust. The Keyword Planner gives you a pulse on what people are searching for online. Use this tool to learn which words and phrases— that relate to you and your artwork—are being searched for online and incorporate those keywords into your website copy.*

- *UberSuggest.org—Enter a query term in the search field and you'll receive thousands of related search terms that people are using for their online searches. Try searching for "heirloom tomatoes" just to see the variety of sites that pop up. Then, search for terms relevant to what you make. If blogging is a part of your marketing plan, this tool is a brilliant option for brainstorming blog topics.*

- *YouTube.com—People often forget that video is one of the most used search tools for finding the latest trends and interests. If you're considering using video for your marketing, research the videos for your genre to see what's popular.*

- *Omgili.com—This search tool lets you search forums and discussions to find out what your customer is talking about.*

In conclusion, learning about and understanding your customer audience can be an in-depth process. The best way to get started is to increase your opportunities to engage with prospective buyers in person and online. Next up, turn your audience knowledge into a compelling brand.

visualize

PART 2:

Opportunity

"Endeavor to be
what you desire
to appear."

— Socrates

CRAFTING A BRAND YOU BELIEVE IN

MARKETING II

It caught my attention out of the corner of my eye. While browsing the Google image search results for "handmade cards" and "artist thank you cards," one picture managed to stop me in my scrolling tracks nearly three-fourths of the way down the search page.

A crisp, clean image of four vertical greeting cards standing boldly against a clean white background looked like something out of a magazine. Just a few images to the right, the same style and vivid colors with white borders against a black background connected the dots and created a lingering impression.

The colors and contrast caught my eye. But the professionally executed photography is what drew me in and elicited a "click."

To learn more about painter Melissa McKinnon, visit melissamckinnon. wordpress.com. And find her on social media:
- Pinterest.com/ MMcKinnonArtist

- Twitter.com/ MMcKinnonART

- Facebook.com/ MelissaMcKinnonArtist

- Etsy.com/shop/ MelissaMcKinnonArt

The image led to a webpage that was equally crisp, clean, and bold. Bright blotches of pure hue saturated the site of independent artist, Melissa McKinnon, who paints and sells out of her home studio in Alberta, Canada.

Melissa's images, paired with my Google search terms, made a connection in the right place at the right time. Someone like me—not necessarily searching for artwork at the time—happened upon her website as a result of serendipitous searching.

The connection to Melissa's artwork could have ended right there in the search browser. Instead, the images opened the door for Melissa to gain a new admirer and for me to have another chapter case study. The professional approachability communicated by Melissa's website, paired with the branding consistency across all of her social media platforms quickly converted me from being a mere website viewer just moments earlier to being a fan.

Melissa's brand is explicitly stated through her stylized graphics, fonts, and online presence; it is a reflection of her artistic style. Her brand is implicitly shared through her communications, customer relationships, and the thoughtfulness that goes into every business detail; her brand is a reflection of her personality.

The branding and direct communications Melissa employs in her marketing keep me returning to her website to see what new artwork is available and what's happening in her life and career. As a new fan, it is easy to entertain the idea of owning a piece of her artwork while scrolling through images of canvases placed in living rooms and show spaces. She makes it easy for the viewer to aspire to collector status.

Creating a well-packaged brand that gives attention to both your artwork and to you as the artist makes a world of difference to prospective buyers, especially those who find your artwork online.

People want to know who the artist is, and they want to understand how the artwork fits in with their lifestyle. This information is particularly important when website viewers see your work for the first time thousands of miles away from the work itself. It only takes three seconds for someone to form an opinion of you and your work based on a single visit to your website. Thoughtful, memorable branding is the key to standing out from the crowd.

"Brand messaging" exists nearly everywhere in our Western lives. It is visible on labels and on packaging. It is on billboards when we drive down the highway. It is on television, in commercials, on the radio, and online.

But it's not just limited to the visual. It's what we hear. Sounds associated with certain companies—NBC's "ding, ding, ding," De Beer's jewelry's classical music theme song, Intel's trademarked "leap ahead" sound.

When "brand messaging" is consistent, recognizable, and arrives with regularity, we learn to associate when, where, and how it should show up in our lives because we are pattern seekers and creatures of habit. When brand messaging is strong, we carry brand messaging associations with us in our minds, whether we realize it or not.

Just think about the strong associations tied to the holiday season. Does anyone else get excited to see a Coca-Cola truck drive by with wintery polar bears on the side?

In the past few years, we've had specific days surrounding the holidays branded to affect our buyer behavior—Black Friday, Small Business Saturday, Cyber Monday, and Giving Tuesday. What's next? "Why Did I Just Spend So Much? Wednesday." Branding touches us on many levels, creating emotional resonance and meaning out of thin air.

Branding refers to the process of developing *positive* and *specific associations* in your target customers' minds. For brand awareness to occur in their minds, they must experience a combination of consistency, recognizability, and frequency with what you make.

brand awareness =

consistent + recognizable + frequent

This is your *Brand Awareness Formula*, and the combination is pattern forming. Brand awareness creates meaning, particularly when someone takes time to engage with your craft and has frequent encounters with it and with you.

The best brands sell a narrative that speaks to the consumer experience with the product being sold. Just as abstract expressionist painter Mark Rothko speaks about a painting being not about an experience but rather being an experience in itself, a brand is an experience.

What experience do you want your audience to have with what you do? What pieces of the story do you want to highlight for your audience? What elements add value and elevate your artwork?

As an artist, you and your work are your brand—your style is your copyright. Curate the experience people have with you and your artwork through your marketing. Doing so will give your audience consistent exposure to your art—making it recognizable in viewer minds so long as it shows up with regularity.

FOURTEEN WAYS BRANDING CAN ADD VALUE TO YOUR CRAFT

Branding...

1. *positions you as a professional artist.*
2. *elevates your artwork in the mind of your buyers.*
3. *establishes your expertise in your field and genre.*
4. *adds more value to your offerings.*
5. *packages and frames your artwork.*
6. *inspires consistency and understanding in the mind of the viewer.*
7. *shapes the way people perceive the cost of your artwork.*
8. *informs the type of venue your work will be displayed in.*
9. *helps your artwork stand out.*
10. *makes your artwork even more memorable and attractive.*
11. *creates additional meaning for your audience.*
12. *attracts the right buyers and opportunities.*
13. *tells a story.*
14. *tells your story.*

Need help creating a logo and brand style? Use the expertise of graphic designers listed on 99Designs.com and eLance.com.

THE ART OF BRAND STORYTELLING

A brand is more than a logo design. A good brand will magnetize and attract. People will identify with it and want to be a part of it. Leading companies know this, and those with the budget spend millions of dollars creating a personality that expresses the brand they tout and the values they claim. Big companies also know that people buy based on emotion, so they develop messaging that penetrates the skin and reaches people's feelings.

Here is where artists have a significant advantage—artists already have personality and a natural ability to empathize and inspire. If you are excited and passionate about your work, subject, and medium, other people will be too.

Before you proceed in crafting a brand identity, ask yourself the following questions:

- *Should I create brand awareness around my name?*
- *Should I create brand awareness around my studio or company name?*
- *Should my brand combine my name and my studio/company name?*
- *Should I craft a brand around my techniques and my concepts?*
- *Should I craft a brand around fictitious characters in my artwork?*
- *What should my brand storytelling be about?*
- *What feeling do I want people to associate with me and my artwork?*

If you are building brand awareness around your name and around what you make, your story and personality are irreplaceable. Genuine personality and intuitive perception aren't manufactured and, therefore, don't require millions of dollars to create audience connection. Instead, they require time investment in turning personality and emotional connection into storytelling: messaging and imagery that align with your values and attract your target audience authentically.

Here is where such exercises as *My Story: At Least 20 Things* from Chapter 2 come into play. You are fully equipped with a lifetime of influences and experiences that have made you the artist you are today. Packaging them into communication that speaks to your customer and adds a deeper understanding of your artwork supports the brand you are creating because people are just as interested in the artist as they are in the art itself.

Keep in mind your knowledge of your audience, your past accomplishments that contribute to where you are at the present moment, and your aspirations to position yourself strategically within the marketplace. Use these three elements to craft the narrative of what your creative endeavors are about.

ALIGNING YOUR BRAND WITH YOUR MARKETPLACE POSITIONING

As you may recall from earlier in the book, marketplace positioning accounts for the perceived value of one's offerings compared to what else is being offered to the same market. Positioning allows sellers to set their brand perception as high-end, low-end, and middle of the range. Knowing this, an artist should price for the market to which he or she wants to sell.

The same is true of branding. Brand for the market you want to be in. Your customer is aspirational; purchasing original artwork is something many aspire to do. For examples of high-end, low-end, and middle of the range branding, flip through a few magazines that are tailored to different groups of people. Here, you will find lots of branding and marketing inspiration to inform the direction of your own brand.

Visible vs. Invisible Branding

A brand is created from many cohesive elements: those that are explicit and visible, suggesting identity, and those that are implied and invisible. Use these lists for reference to differentiate between the two types of branding:

VISIBLE BRANDING

- ☐ *marketing materials and collateral*
- ☐ *digital marketing*
- ☐ *a website*
- ☐ *photographs*
- ☐ *fonts, graphics, imagery*
- ☐ *packaging*
- ☐ *customer relationship style*
- ☐ *communications*
- ☐ *sponsorship opportunities*
- ☐ *public relations*
- ☐ *vendor selection*
- ☐ *material quality details*
- ☐ *collaborations*
- ☐ *advertising*
- ☐ *place of sale*
- ☐ *customer experience*

☐ INVISIBLE BRANDING

- ☐ *vision, mission, principles, and goals*
- ☐ *pricing strategy*

Leveraging Your Creative Work to Create Your Brand Essence

When your style is your signature, it comes from a place of authenticity that is difficult for others to replicate. Your inspirations, influences, and processes are solely yours. While hundreds of others may be attracted to the same inspirations and influences, and may even have a similar process and medium, the degrees of variation within this combination make each artist unique.

Let's look at an example from a different industry altogether. In the wine industry, thousands of producers from all over the world package their annual vintages under their winery's label each year.

A single year in the wine world accounts for hundreds of geographic regions. Within those regions are a number of appellations with a few handfuls of vintners producing wine from a number of variables: soil type, grape variety, pesticides or no pesticides, amount of sunshine, etc. While these producers operate in similar conditions and often use the same machinery, their winemaking style is what makes every bottle different—even when they are using the same grapes. The wine label is a visual reflection of the vintner's style.

The artist, like the vintner, uses strengths, knowledge of medium and materials, inspirations, etc., to create a one-of-a-kind product. It behooves the artist to infuse his or her art into his or her brand. Your brand should be a reflection of your style. Your style, after all, is what people associate with you.

You can use your art, knowledge of self, and desired marketplace positioning to create a brand, beginning with your branding baseline.

Your Branding Baseline

It is said that a picture is worth a thousand words. And yet, the same can be true of a single word, which can conjure up thousands of memories and associations. So imagine the power of three to five words, plus a few accompanying pictures.

That's a lot of communication stuffed into a concise, efficient, dynamo package called "branding."

What words would you use to describe your art and thus your brand? Choose three to five. These words will become the baseline for your visible and invisible branding, and they will craft what is referred to as your "brand essence."

The book, *Style Statement*, by Carrie McCarthy & Danielle LaPorte is a helpful resource for learning more about how your style influences your branding.

To help you find three to five words that reflect your art and fit your brand baseline, read the following words aloud to gain a sense of how they resonate with you and what they imply. Then, choose your own words for your branding baseline.

experience savvy
discount perfect
aged timeless
fluffy

craftsman
artisan bright fun
whimsical glossy
short-term fast-paced

playful traditional
cherished
radiant
modern

dramatic
theatrical inquisitive
reliable rustic

chic fresh
vivid luxury
soulful raw

simple designer

 elegant avant-garde
homey bold

childlike
dreamy signature
 sophisticated earthy

For more branding inspiration, head to my Pinterest page: Pinterest.com/ heather_allen/ branding-inspiration/

 harmonious embossed
 powerful tailored
 polished

romantic elite worldly
 recycled detailed

Using Pinterest & Polyvore to Inform Your Brand Direction

For the visually inspired, an image or object collage can be helpful for bringing branding inspiration to life. Some visual inspiration can be particularly useful to those attempting to harness a brand essence solo. Bring in your responses from the *Marketplace Snapshot & Key Differentiators* exercises (see Chapter 6) to help you align your visual brand inspiration with the way you want to be perceived in the marketplace.

Pinterest (www.pinterest.com), while known for its social sharing functionality, is an excellent tool for collecting visual inspiration in one place. The impulsive nature of "liking" and "pinning" anything your heart desires onto your own Pinterest boards means you are reacting to your style preference without too much analysis. Use Pinterest as a place to collect brand, marketing, and project inspiration. It may just help you synthesize your creativity and pair words with your style.

Like Polyvore (www.polyvore.com), Pinterest is a social sharing site, but it takes pinning further by placing objects and images into digital collections and collages. This means you can create your inspiration sets within the framework of a digital canvas, and you can use them to display your art inspiration and creative direction. This tool is especially helpful to bloggers who want to add imagery to their blog posts.

> A few budget-friendly graphic design tools to check out are PicMonkey.com, Canva.com, and Piktochart.com.

Designing a Digital Brand with DIY Graphic Design Tools

When you have visual and verbal elements, such as images from a magazine or a collage, along with your artwork, you have a foundation on which to build your branding. It used to be that executing the design of a brand was very costly and left only to professionals. Now, with the help of a few digital tools, it is easier than ever to DIY (do it yourself).

While I advocate for using the skills of digital design professionals in areas like website and graphic design, the options available to those with limited budgets have the power to give you a professional look as well.

PACKAGING YOUR OFFERINGS TO ELEVATE YOUR BRAND

If you are selling online or using your website as your primary marketing tool to sell what you make, your photography has to be top notch. Good photography elevates your artwork and justifies your asking price. Your photography should be at least as good, if not better, than the work itself.

If your art is highly detailed with very small elements, use a macro setting to highlight your detailing and give people an up close view of your work. If your art is large, give people a sense of scale by contrasting your art with an everyday object—like a chair—so your viewers have the full magnitude of what you make. Installation photography communicates a lot of information about your art, too.

Your photography should also be styled to match your branding. If you are selling handcrafted wooden bowls and your branding words are *retro*, *utilitarian*, and *earthy*, stylize your marketing photography to showcase those descriptives and build the storytelling of your product. Dropping an Instagram (www.instagram.com) filter over a photo of a set of bowls nicely stacked on a picnic table in the woods invites the imagination to play. Or if you are selling minimalist paintings, keep your photography minimal with a focus on the painting in a clean, simple setting.

BRINGING YOUR BRAND TO LIFE

A brand is an opportunity to bring your prospective customers into your world and give them something to whet their palate. Your brand can come to life in a number of places, and just like with your artwork, the key is consistency.

Your Website (visible branding)

See your website as an extension of your art, and use it to communicate with your audience. You can no longer get away with letting your website be stagnant and unchanging.

If your audience is comprised of New York City gallerists, use a clean and simple website that lets the art do the talking. Look to the artists whose work is found on OtherPeoplesPixels (OtherPeoplesPixels.com) for direction.

If your audience is more likely to be gift givers, you may want an eCommerce website through which people can purchase small items directly. WordPress.com or Squarespace.com may be good solutions to your eCommerce needs. Think about your audience before choosing and designing your website.

Packaging (visible branding)

Packaging separates hobbyists from professionals. Why? Because packaging implies moving work from your studio into a buyer's possession. If your packaging is the first thing people experience as they unwrap your art or craft, your packaging should elevate your artwork. If it is associated with your artwork, it should elevate and highlight your artwork much like a frame elevates and highlights a painting.

Online & In-Person Checkout Experience (visible branding)

Point of purchase should be seamless and simple. To keep your customer happy during and after a transaction, integrate an easy-to-use checkout system. For more information on eCommerce, see Chapter 10.

Email Marketing & Social Media (visible branding)

Email marketing and social media are tactical methods for staying in touch with buyers new and old. And because your website visitors may want to stay in touch with your brand by subscribing to your email list or connecting on social media, your brand should translate from your website to those places as well.

Collaborations (invisible branding)

Collaborations are excellent opportunities to elevate your brand by associating it with another brand. Whether it be a partnership with another artist, involvement with an organization, receipt of grant funding, features in a publication, or volunteer work with a charity you support, collaborations can position your brand in powerful ways and give you exposure to new audiences.

Business Cards (visible branding)

It goes without saying that having a business card is essential. But as simple as a business card is, be sure your card is tailored to your market, fits within your industry, and carries your branding. A disc jockey's business card will have a different look and feel than that of a children's books illustrator. Someone who designs luxury handbags will have a card that reflects luxury versus someone who designs bags with recycled materials.

Reference the exercises you completed in Chapter 7: *Crafting a Brand You Believe In* to create a business card your target customer identifies with. If it helps, take a look at business card examples from other artists in your genre.

Rack Cards (visible branding)

Rack cards are especially helpful if you sell artwork from an open-to-the-public studio or through tradeshows, markets, and fairs. A rack card gives your customers an information piece to take with them. Rack cards can also be left behind with the students you teach and those you share a lecture with.

Effective rack cards are well-branded and include high-resolution photography. If you have an "about" section on your website, or a detailed description of yourself and your work, a rack card is a great place to mirror this information. Rack cards typically include location information for brick and mortar businesses and your company website.

Postcards (visible branding)

Some may argue that postcards are out-of-date because people don't use snail mail anymore. I would argue that any physical reminder of your artwork that can be left with others is invaluable.

Branded postcards can be used to market upcoming shows and events related to your work. They become an extension of your website and studio because they can hang out in the places your customer is likely to traverse. Additionally, they can serve as a marketing handout for studio visitors after the show.

To cover your bases, be sure to include an image or a cluster of images of your artwork, and the who-what-where-why-when. And always include a link to your website.

In-Studio Signage (visible branding)

Don't forget about the opportunity to sear your brand and name in the studio visitors' minds. Use window and/or door signage outside of your studio for the casual passerby and those looking for you specifically. You may also want to make a few rack cards or business cards available to those who visit your studio when it is closed.

Here are a few places your brand can come to life:

- ☐ *Website/Blog*
- ☐ *Facebook banner, profile image, apps, and messaging*
- ☐ *Twitter banner, profile image, and messaging*
- ☐ *Instagram banner, profile image, and messaging*
- ☐ *Pinterest profile image and messaging*
- ☐ *Other social media accounts*
- ☐ *Email marketing*
- ☐ *eCommerce checkout process*
- ☐ *Product Packaging*
- ☐ *Business Cards*
- ☐ *Print Marketing*
- ☐ *Studio signage*
- ☐ *Marketing Materials*

Print on Demand Companies

- ☐ *GotPrint.com*
- ☐ *ModernPostcard.com*
- ☐ *VistaPrint.com*

DIY Graphic Design Tools

- ☐ *Picmonkey.com*
- ☐ *Canva.com*

Website Platforms

- ☐ *OtherPeoplesPixels.com*
- ☐ *WordPress.com*
- ☐ *Squarespace.com*

"Get someone else to blow your horn and the sound will carry twice as far."

— Will Rogers

CHAPTER 9

ENGAGING YOUR AUDIENCE ONLINE

MARKETING III

To transition into a new phase in his career as an art writer without devaluing his identity as an artist—or become the subject of the "failed artist turns writer" scarlet letter—Loren Munk created the pseudo-critic and art world persona, James Kalm. "James," Loren's middle name, and "Kalm," his wife's maiden name, became Loren Munk's leading voice as a New York City arts writer. For Loren Munk, operating with the persona, James Kalm, created a line of division between his art and writing. He is a regular contributor to the *Brooklyn Rail* and *NY Arts*.

I first learned of Loren Munk through the video testament of James Kalm who, while touring the Outsider Art Fair with video camera in hand, narrated everything we viewers at home needed to know about the fair and who was showing.

To learn more about Loren Munk/James Kalm, visit his website at LorenMunk.com. And, find him on social media at: YouTube.com/JamesKalm

YouTube.com/ JamesKalmRoughCut

Facebook.com/pages/ The-James-Kalm- Report/46938493442

I liked Loren's work. I thought it was brilliant—living art history coming to life through speech bubbles and text on canvas. It was easy to recognize, and it resembled nothing I'd seen before, except for perhaps a condensed illustration of a city attractions map paired with trendy infographics and a chatty cartoon strip.

Subsequently, Loren's iconic style caught my attention again while reading *New York Magazine* on a flight to New York—ironically, in a full-page spread featuring one of his New York art scene maps. Seeing Loren's art in a few other places within a condensed period of time made it all the more interesting to me. My encounters with Loren's artwork were becoming more frequent.

Loren's departure from himself as the artist gave him a platform to write and speak freely as an art world commentator. This method of promotion, with the aid of YouTube, also exposed Loren's work to viewers outside of the City.

Vlogging (video blogging) is Loren's primary means of promotion for both his work and the New York City art scene at large. With two YouTube channels that house "The Kalm Report," Loren Munk/James Kalm has accumulated over 3 million video views since launching his channel in 2006.

Self-promotion is one of the most commonly faced challenges for self-employed artists. I've heard many artists and craftspeople tell me they avoid marketing their work because they don't want to appear boastful or self-aggrandizing. I understand this sentiment completely.

If you take the word "marketing" and turn it into "communicating," or even "inviting," then it becomes more an act of sharing and welcoming than an act of bragging and promoting. Communication and invitation can take on many forms, becoming what is seen, heard, felt, and experienced between you and your fans.

People don't like to be sold to, but they do like to learn things. What can you share with your audience that deepens its understanding of what you do and make? When your focus is sharing, self-promotion becomes a by-product you may not even notice.

When I started my business at the intersection of arts and promotion as an artist agent, I was oblivious to the fact that what I was doing was known to many as "marketing." I was over-the-top with excitement about the artists I was working with and the work they were doing. So excited that speaking about their work, finding opportunities for their work, and sharing their work was done out of pure joy. It only became apparent that my role was one of marketing and promotion when people started coming to me for that reason specifically.

Using communication and invitation as a means of marketing allowed me to foster relationships with those interested in the arts and in the artists I worked with. It also opened the door to community and opportunity. Enthusiasm is a great excuse for sharing and welcoming people into your world.

Enthusiasm is a prerequisite to authentic promotion. It draws people in and gets them talking: "Did you see that show So and So put on?" "Did you RSVP to So and So's annual studio sale? I hear it's going to sell out."

It starts with one person's enthusiasm for a topic. Enthusiasm turns into communication, and suddenly, everyone is talking about the same thing: you. This is Word-of-Mouth Marketing, and it is the best form of marketing out there.

Much like the enthusiasm for the artist clients I started my business with, and Loren Munk's enthusiasm for documenting gallery shows and art world relationships, there are topics you feel enthusiasm for too. Perhaps it is your subject matter or your medium. Maybe it is the life your artwork takes on once it finds a home with its buyer. Or maybe it's the way you

make people feel through capturing special moments in their lives in your commission work.

Some essential attraction fuels the reason for what you do. It is called passion. Those who are passionate about what they do rarely tire of the topic or see it as work. View marketing as the passion that generates enthusiasm, which turns into communication and invites others to participate. The participation of others is vital to anyone who wants to maintain a full-time income doing what he or she is passionate about.

YOUR WEBSITE: THE HUB OF YOUR ENGAGEMENT WAGON WHEEL

Outside of in-person interaction, most would argue that their website is the number one place people find out about their artwork, and the first place an artist will send inquiring prospects to learn more. With this in mind, think of your website as the hub of a wagon wheel for all of your marketing efforts. The wheel itself represents the touchpoints of exposure people can have with you and your work, in-person and online. The spokes of the wheel are the channels that draw people into one central location—the hub—which is a single, manageable location for learning more and getting in touch with you.

Here is your strategy: Keep it simple. Every opportunity to connect leads to the same place where people can receive message consistency. All of your social media efforts, print marketing materials, PR, signage, and verbiage can link back to that hub—your website. As we discuss social media's role in your creative business later in this chapter, think about how social media can direct people to your website.

The biggest benefit of your website acting as the primary marketing representative of you and your artwork is that you have control over the content published there. You own it.

Unlike Facebook and a number of other social media sites that own the content you create, your website listens to you and is a reflection of what you need it to be. Your website can be your best salesperson.

Most people depend on a website to drive business. I know one or two artists who have managed a successful career without a website, but their careers began before websites existed.

A website is a marketing tool, and yet, gone are the days when an artist or a business throws up a website, says, "It's up!" and then calls it quits. A website can no longer be seen as another checkmark on a long list of marketing to-do's because if it is treated as just another thing to do, it will outdate itself quickly. If your artwork and resume are evolving, your website needs to be too.

Independent artists who sell directly to buyers can leverage search engine optimization (SEO) to draw in more viewers—and prospective buyers. When your website is rich in words people may associate with your artwork, "search serendipity" increases. This happens when people stumble onto your website while browsing the Internet and are pleasantly surprised by what they find. If your site becomes exactly what they need (even if they weren't looking for it), you've got a win-win.

Search serendipity increases proportionally with the amount of relevant content on your website. The more you have on your website, the more "searchable" content you have for browsers and searchers to stumble upon. Blogging is one way to increase the written content on your website without cluttering or overshadowing your craft.

BLOGGING: MARKETING THROUGH YOUR COLLECTOR'S EXPERIENCE

Blogging attracts new people to your website by connecting the topics you write about with the topics people are searching

for in a search engine. If people are searching for a topic and serendipitously happen upon your website and blog, you've earned a new site visitor, a new connection, and a possible new buyer.

Blogging sets the stage for your creative work to come to life in new ways. It's also a place to market to new customers by sharing your collectors' experiences with your art:

- *How did your last buyers find you?*
- *What did they purchase?*
- *Why did they purchase it?*
- *How does their purchase look now that it is installed in their space?*

There are rich stories within your own selling and showing experiences that can lead to more and similar experiences.

Marketing through your buyers' eyes can lead to increased sales and fan loyalty. Showcasing your buyers and sharing their experiences with your work is a subtle means of marketing because it's not about you. It's about what you can do for other people.

Take photos of the places your artwork comes to life in the lives of your buyers to create blog stories and visual experiences with supporting images. Beautiful photography goes a long way and saves you words by painting the picture for your blog readers.

Or if your inspirations come from a certain color palette, write about the pieces you are creating that use those colors. Take pictures of your process to give people a deeper appreciation of the thought that goes into a piece. Process pictures will educate your audience and help them connect with your work. People love the behind-the-scenes storytelling of making art. Similarly, photographing your finished pieces in different environments expands the viewer's definition of where and how your works fit into different settings, making

it easier for them to imagine a piece in their dining room, corporate suite, or gallery.

Another way a blog can support your marketing is by answering customer questions:

- *How long does it take to receive a commissioned piece?*
- *Are all of the pieces you make originals?*
- *Do you ship internationally?*

A blog can also be a place to showcase your artwork in a daily or weekly posting of works in progress and completed pieces. This frequency will give people a reason to revisit your site to find out "what's new." It will also keep the engagement door open, thereby building your brand awareness.

But blogger beware. Creativity comes in waves. If you want to make blogging a focus, collect ideas for your blog post topics in advance. Think of all the topics that could come from sharing your process:

- *The behind-the-scenes details of your work.*
- *Your production methods and materials.*
- *Your "day in the life of the artist" stories.*
- *Your inspirations and experiences.*
- *The works of other artists and people you admire.*

A blog invites people into your creative world and gives them a reason to engage and come back. Like social media, a blog is especially interesting when online engagement and in-person connection overlap.

Even with all of these ideas and incentives for writing a blog, blogging can be a lot to keep up with. So how does one sustain and maintain a blog without burning out? By using a secret planning weapon that keeps you creating and sharing relevant content on a regular basis—a calendar!

WordPress users can install the "WordPress Editorial Calendar" plug-in; it allows your scheduled posts to display as a calendar grid rather than a list. This free tool may help you match your "life" calendar with your publishing calendar.

PLANNING AHEAD WITH AN EDITORIAL CALENDAR

Have you ever followed a blog that publishes great new content daily or weekly? Have you thought to yourself, "How do they manage to publish great stuff so often?"

The truth is that most blog writers who publish blog posts on a regular basis don't plop down to the computer first thing in the morning with great ideas in their heads. Instead, they plan and schedule posts that publish automatically, even when they are away on vacation without a blogging worry in the world.

Planning ahead with the help of an editorial calendar gives bloggers a chance to think like a publisher. In doing so, blog writers can capitalize on creative highs when they have them, and they can publish existing material during dry spells and writer's block. It also helps to maintain a realistic blog publishing frequency and format. Blogging can also be as simple as uploading your latest pieces for sale.

So how does one start an editorial calendar? And what type of information goes into one?

An editorial calendar can be whatever you need it to be. Depending on how frequently you plan to post, and what you want to share, one method for starting an editorial calendar is to begin with a month in the life of you—the artist. Take next month, for example. Do you have any newsworthy events coming up that you could craft a few posts around? Do any of your peers have showings or stories worth telling? Do you plan to start or finish a piece or series?

When you plan blog posts around your existing schedule, a blog can work as a means of elevating what is happening by sharing the experience before and after it happens. Take advantage of this by indulging readers with details and sharing photography. Help people to see the bigger picture of what you do and make by bringing your artwork to life in your blog.

Another use of an editorial calendar is as a tool for scheduling and planning your overall communications. If you want your blog to support your email communications, and vice versa, an editorial calendar will help you coordinate all of your messaging. This tool gives your marketing and communications one centralized planning place.

CREATING STRATEGIC SERENDIPITY WITH SOCIAL MEDIA

Over the past few years, social media has evolved rapidly, implanting itself as a fixture in our lives. Some plug into social media daily; others hourly or minute-to-minute. Social media has had a tremendous effect on how we communicate, share, and receive information. Many of the leading platforms used today are literally in the palms of our hands, making it even more compelling to transmit a thought to the world with the touch of a screen.

While social media is a prominent means of communication for millions of people worldwide, each social media platform provides its users with a different environment to communicate and, therefore, a different communication experience. It is best for those planning to use social media for business and brand elevation to do so with a strategic sense of how the platforms differ and operate individually.

The truth is that you don't need to be on every social media platform. It's better to understand which platforms will best elevate your artwork and connect you with your audience so you get an optimal return on your social media time investment.

Social media is different from any other conventional marketing tool. Essentially, the depth of interaction and connection with your audience is greater than in conventional media because of the two-way nature of being social. The feedback loop is on and conversation is real. This factor in itself is a powerful advantage that can take your business far and give you an edge by increasing your network and brand awareness online.

This difference also means that to be successful with social media, your thinking and approach must be different. The premise of social media is to be social. The same rules of engagement that apply to in-person connections apply in social media. In other words, it is not enough just to be on social media feeling your way around; to make it worth your while, let your social media presence be a continuation of your in-person interactions and relationships.

Often, the best social media engagement doesn't happen in studio isolation; rather, it is an integral component of "in person" activities. Loren Munk makes this engagement possible by taking his video camera with him to gallery shows and sharing real experiences with a real audience afterward.

Serendipity is going to happen. In social media, serendipity is a given—it's like showing up to a party that everyone is already at. In using social media, you are bound to make meaningful connections. People will find you and your creative work through social media should you choose to incorporate social media into your communication plans. When people find you, the doors of possibility will open.

Additionally, you will find opportunities for your work through those who elevate your brand and story by sharing it with their audiences. Let your social engagements be natural, strategically natural, just as they would be in any other social environment where some people have an agenda and others are just there for the free beer.

Here are a few pointers to help you direct your social media communications strategically:

- *Remember that it's not all about you. Strategic social media is about elevating others—paying it forward. It's a "promoting without self-promoting" tool that inspires connection.*

- *Share your passion, your inspiration, and your gratitude. Social media is a great place to do all three.*

- *Approach social media and fan engagement as a dialogue. Most social settings lend themselves to sharing. The same etiquette applies to social media environments.*

- *Be a great listener and observer of your market if you want to be a good communicator with your customers. In his book,* Permission Marketing, *Seth Godin says, "When someone chooses to pay attention they are actually paying you with something precious."*

- *Engage by commenting and sharing from a place of authenticity and relevance.*

- *Do one or two things well rather than doing several things poorly. You don't need to be everywhere on social media.*

- *Make the most of your time on social media by intentionally engaging where your customers, buyers, and collectors are. This will help them to find you more easily.*

Much like using an editorial calendar for blogging and email communications, your social media communications can follow existing themes and plans already in place in your professional life. One method for managing and scheduling your social media communications is to use a dashboard like Hootsuite to get a big-picture overview of all of your social media channels in one place.

> Hootsuite.com can make your social media posting life a little easier—it's all in one place.

179

Beefing up Facebook for Business

Facebook is the gateway drug to social media. It is typically where people start before they use other types of social media. Facebook began as a free, online network for college students to stay in touch with other college student friends. It quickly expanded to much of the digitally connected world.

According to *The Guardian*, by the end of 2013, Facebook exceeded 1 billion users globally. With businesses using Facebook to reach customers, Facebook has become the prominent leader in social media communications. Considering Facebook's market pull, it's likely that a majority of your buyers, fans, and collectors are using it too.

Facebook business pages—such as that of photographer Shannon Johnstone, who started a project page called Landfill Dogs—typically benefit from audience engagement that develops naturally. The page administrator learns the ebbs and flows of posting content and moderating comments. Despite having such a large following, Shannon posts a few times each week, rather than a few times per day, to keep her audience engaged without overwhelming fans with her brand messaging.

A major advantage of using Facebook for business marketing is that it's a platform for interaction with your audience. For those just beginning to use Facebook to engage with their audiences, here are a few pointers, republished from my article in *The News & Observer's* "Ask the Experts" column:

> First, think of your page "Likes" as supporters and fans. People who voluntarily "Like" a Facebook page do so because they appreciate what is being shared there. People buy from those they know, like, and trust, so value "Likes" as you would any prospective collector or fan. Many artists have sold artwork directly from their Facebook page.

Next, use a Facebook business page rather than a personal page to promote your artwork. A business page positions artists as professionals rather than hobbyists, giving them more credibility. A page also expands "Like" potential versus a personal profile where people connect as "friends"—an association that is limited to 5,000 connections. Furthermore, a business page is also a brand management tool that gives artists control over what is posted on their pages.

Facebook encourages an atmosphere of engagement and conversation. Jewelry artist Kathy King shares her inspirations, travels, shows, and workshops as a beading instructor, along with the work of other artists she admires. She receives and responds to comments, and uses Facebook to drive conversation.

Be creative with how and what you share. The world is hyper-visual, which means artists are well-positioned to capitalize on their skills by sharing visually. Know your audience and share what inspires others to share.

Brand your Facebook page using your own artwork. In three seconds or less, people should be able to understand what your page is about. Customize the cover image and tabs to reflect your artistic style.

Last but not least, "Like" other pages to show support. Facebook is a social tool that can be used to engage and support those outside of your circle. "Liking" and commenting on the pages of respected organizations and artists shows community engagement and is a subtle means of self-promotion.

To learn more about Kathy King, visit her website at KathyKingJewelry.com. And find her at Facebook.com/pages/ Kathy-King Jewelry/128705700478797.

Taking Tradeshows, Markets, and Fairs Further with Twitter

Like Facebook, Twitter's connective power spans the masses. The prevalence of smartphones and Wi-Fi allows Twitter users to share their messages from nearly anywhere. Unlike Facebook, which chronicles our lives one milestone moment at a time, Twitter is a user-generated water hose of what is happening right now. Tweets are limited to 140 characters, allowing users to read numerous tweets and absorb a volume of information in a very short time—which makes it a perfect tool to take on the go.

As a means of audience engagement, Twitter is valuable for many reasons, but the two I like to focus on are (1) networking and (2) "right now" news reporting.

We'll start with networking. Twitter's "six degrees of separation" "follow" suggestions are based on an algorithm that connects like-minded people, groups, and organizations. If you are an artist working with a specific medium, you may receive suggestions to follow other artists working in the same medium. If you take Twitter with you on the go to a conference, tradeshow, market, or fair where those artists are speaking, showing, and attending, you may have a chance to take your Twitter connections further in person.

As a brand development tool, Twitter gives people an opportunity to "tweet," "retweet," "reply," and "favorite" information, thoughts, and images with others. It also allows people to connect with thought-leaders, organizations, and people in high positions without the filter of a "friend" request.

Anyone can "tweet" to and "retweet" anyone else's tweets. Real human beings read and respond to tweets—Twitter lets you network from your studio. If you are keen on connecting with professionals and organizations in the arts, Twitter may be the best way to introduce yourself online.

In terms of "right now" news reporting, news never traveled faster before Twitter took the stage. In August 2011, an earthquake originating in Richmond, Virginia, shook the East Coast all the way up to New York and parts of Canada.

Twitter users who felt the quake immediately went to their Twitter feed to confirm real-time earthquake news faster than any mainstream news source could.

According to the *International Business Times*, Twitter reported from its own Twitter handle that day that within one minute of the earthquake, nearly 40,000 earthquake-related Tweets had been published.

The engagement environment found within Twitter is unique and open to anyone. Those who choose to use Twitter for audience engagement and networking can build a following, create a fanbase, and open the doors to opportunity.

Turning Pins into Sales Leads with Pinterest

Pinterest popped up as an image-based social sharing tool not too long after Facebook and Twitter. It gradually caught on as a lead-generating tool through its capacity to link back to and reference specific websites associated with "pinned" images.

When Pinterest's popularity began to take off, many people were addicted yet baffled by the tool. They were addicted—let's be honest here, "we" were addicted—because like window-shopping, Pinterest lets users sample everything visually, and pick and choose what they like. Pinterest satisfies wants and desires by offering users the virtual ability to "have" the lifestyle, accessory, handbag, or bouquet of flowers in a handmade vase displayed in the never-ending scroll of images.

At the same time, people were relatively baffled by Pinterest's profit potential for users. What could it do beyond tempting users with eye candy? As Pinterest grew, it found a niche in the DIY and blogger community who used it as a

means of promoting blog posts, and therefore, blog readership and profitability.

From there, other companies and small businesses caught on to the brand awareness power of Pinterest—you can create an entire Pinterest board on your company culture if you want to attract certain types of employees, for example. Companies found a way to leverage the tool to promote their intrinsic values at the same time as promoting their offerings.

Today, Pinterest is like a stylized afternoon picnic potluck to which all are invited. Those who bring the most delicious items to the table—and the most items to the table—whether handmade (original images uploaded as pins) or store-bought (re-pinned from someone else's board) are rewarded by an increase of followers. Followers and those who find your pins may visit your website to see more of what you make.

Artists can use Pinterest successfully in two primary ways. First, by pinning their own artwork, products, and offerings. Second, by creating boards based on certain topics and themes related to their brand—this approach gives you room to get really creative. Artists with visual, tangible offerings can thrive in a Pinterest environment because Pinterest lets users list dollar amounts for the offerings they showcase.

Telling Your Story with YouTube

YouTube came to the computer screen with the uploading of the first YouTube video, "Me at the Zoo," in April 2005, and it quickly caught on as a means of sharing through video.

For people like Loren Munk, YouTube is a tool for storytelling and publishing experiences through edited and unedited video footage. Once a video is uploaded, it can be accessed and watched by any number of people from any number of places.

Because video stimulates multiple senses at one time, people are likely to stay connected to what they are viewing and

listening to. Video gives you an opportunity to bring people into your studio and into your creative process. When people see what you do and hear your voice, their experience with you becomes "real."

Video is especially helpful if you want to give technique demonstrations or sell pre-recorded information. If you can connect with the students of your craft over the Internet and provide them with valuable information, your opportunities to scale and expand your instructor offerings will be limitless.

Using video as a means of audience engagement and promotion allows people to get to know you more candidly, and trust what they are seeing. Furthermore, video gives people an opportunity to share your message with their audiences, thereby expanding your viewer reach.

Showing Your Art, Process, and Behind-the-Scenes on Instagram

Instagram, a photo-sharing application acquired by Facebook in 2014 for nearly one billion dollars, takes an ordinary photo or video clip to another level, letting users share it socially, with or without words.

Because the world is visual, social, and sharing, those with the artistic vision to capture the world and tell their version of it have a gift. Instagram provides a beautiful social platform for artists to share their story, art, and process through images and share their images as art.

Those who excel on Instagram and build a following do so through sharing their best images in a consistent style. Using hashtags (#) and tagging others in images encourages views, "Likes," and follows.

Some artists—such as Creative Director Donald Robertson, whose Instagram handle @DonaldDrawbertson is regularly

featured in the *New York Times* and *Vanity Fair*—create social commentary artwork that is understood by the masses. His style is recognizable, iconic, and easy to "like."

Instagram is truly a creative professional and celebrity's playground, turning a day's work into a photoshoot. People feel more connected with the day-to-day life of those they follow when they see snapshots and images from a person's life. "Behind-the-scenes" images are especially helpful in opening the doors to one's professional life, and creating brand perception.

Mini-Blogging on Tumblr

Tumblr makes posting a no-brainer. Unlike blogging, which requires a little bit of thought for copy and content creation, Tumblr mixes short posts, images, gifs, and video into one mini-blog-like platform.

There's no need to spend hours writing and spell checking when text is at a minimum. Tumblr's short post nature encourages users to post frequently, sometimes several times per day.

CREATING A SOCIAL MEDIA PLAN

Much can be learned and gained through social media. By the time this book is published, new social media sites will proliferate our smartphone and computer dashboards, giving us even more options for engaging.

For some, new social media channels mean new opportunities to engage, promote, and sell. For others, it can be intimidating and overwhelming to manage what's current and keep up with what's new.

Sometimes it's better to keep in accord with the minimalist "less is more" attitude. Once you know where your audience finds your artwork, build a presence in those social media channels and use an 80/20 ratio to share content that isn't

about you 80 percent of the time, and promote yourself and your artwork during the other 20 percent.

Once you understand the various social mediums as well as their strengths, the next thing to do is to create a specific plan and strategy that connects you with your audience and keeps that audience growing.

KEEPING UP WITH YOUR FANS THROUGH EMAIL MARKETING

Email marketing gives artists direct access to their audience, fans, and collectors. Unlike social media, email isn't going out of style any time soon. Permission-based emailing means that email subscribers voluntarily give you their email addresses—and their permission—to receive email marketing communications from you. Earning permission to email the people who are interested in your artwork helps you avoid spamming people and losing fans.

Email marketing is one of the least expensive strategies for:

- *Growing your business.*
- *Staying in touch with existing customers.*
- *Promoting products and services.*

Email marketing works, and it can give any small business guaranteed growth no matter how bad the economy happens to be. As the saying goes, the money is in the list. Many of the people who voluntarily receive email communications from you can be considered prospective buyers. True, not every recipient of an email will turn around and purchase your artwork, but being reminded of your artwork can lead to other opportunities.

Visitors to a website hardly ever buy anything on their first visit. It will usually take many visits and a few email incentives to encourage sales. So when you have a database list of fans you can contact using email marketing, you are a step closer to creating the results you desire.

When you have an email list, you can remind your prospects and customers about your business—in a creative way, of course, without nagging them or bombarding them with your ads. Emails may be sent for countless reasons; it's up to your creativity and planning.

I encourage scheduling email communications to coincide with your promotional calendar, and adding a few personalized, non-promotional emails to the mix. Email frequency is dependent upon your goals and how often you need to be in touch with your subscribers. Sending a minimum of one monthly email is a good start—doing so will give prospects twelve times to be reminded of your artwork each year.

For less than $100, pay to find a good auto-responder (email marketing) service that will guarantee delivery to your list while giving you all the necessary tools to help you continuously build your list. It's better to have a small email list of likely fans and buyers than a large list of people who aren't interested in your offerings.

Most auto-responder email marketing providers offer consumers a variety of web-based options for sending spam-free, designed email messages and newsletters. A few easy-to-use email-marketing options to choose from are:

- *MailChimp.com*
- *GrowaFanbase.com*
- *Aweber.com*
- *InfusionSoft.com*

While it is easy to send a mass mailing, it is more difficult to curate strategic email messaging that is relevant to the reader.

First things first. Before sending email to a large group of people, ask yourself: (1) What are my email marketing goals? and (2) Why would this large group of email recipients care to hear from me?

Email marketers need to understand their audience; audience clarity makes it easier to send relevant email messages. Here is where understanding customer persona-types comes into play.

YOUR MOST VALUABLE INTELLECTUAL PROPERTY: YOUR EMAIL LIST

The value of a business is not only in the product or service it provides but also in its customer or client base. If there are no clients or customers, there is no business. In many instances, sales will ground to a halt without a steady flow of good sales leads. Thus, having a database or identifiable pool of potential clients or customers is a basic and valuable tool in growing any business inexpensively.

Email marketing should be a primary focus for your marketing and sales funnel. Most people have an email address. It would behoove any artist to have a highly visible email subscribe opt-in on his or her homepage or website footer. Your Facebook page is another place fans and collectors may frequent. Give your fans the opportunity to sign up for your email list directly from your Facebook page by integrating an email sign-up in the Facebook apps section of your page.

Artists who collect email addresses in a guestbook at shows and events have the opportunity to follow up with new subscribers in a branded "Thank You" email soon after the event. Initiating engagement invites people into your world.

Keep in mind that it is much easier to get business from an existing customer than from a brand new one—another reason to value your customers as long-term collectors. But your efforts to do so will be supported as you learn more about who your people are.

While it may not be a good idea to ask for more than a name, email address, and location when developing new relation-

189

ships with prospects, you'll benefit from learning more about your fans in the long run. Using a CRM (customer relationship management) system, as mentioned earlier in this book, will help you keep detailed records of your fans once they become collectors.

One of the advantages of initiating communication through email and collecting customer information as the relationship matures is that you will end up with a fairly accurate profile of who your typical customer is. This will benefit your efforts to get new customers because you will know exactly what to look for, where to show up, and how to engage new fans in the future.

Much like branding your Facebook business page to reflect the branding on your website, infuse your email marketing with your artwork and brand so people more easily recognize where the message is coming from. Artists can capitalize on the use of a large image or multiple images in an email to grab viewer attention. This draws people into promotional email messages, special invitations, and offers.

LINKEDIN ENDORSEMENTS: MARKETING TO YOUR COLLECTOR'S EXPERIENCE

Testimonials tell the short story of what working with you is like. Just as blogging can be a means of marketing through your customer's experience, showcasing customer testimonials markets the customer experience to new customers and professional opportunities that want to know more about you.

LinkedIn is one of the best professional social networks for showcasing testimonials. It comes complete with a recommendation tool that your existing contacts, friends, and colleagues can use to affirm your credibility. Endorsements collected on LinkedIn can also be published to your website. No other online medium builds professional reputation as effectively. Customer reviews can make or break a business. Whether walking into a brick and mortar establishment or shopping

online, customers want the reassurance of thinking it is worth their time.

For fine arts artists in particular, testimonials support professional credibility. When three or four collectors, respected peers, critics, jurors, or arts organizations give you their highest recommendation, your clout and influence elevate tremendously.

Testimonials have the ability to provide a glimpse into happy customer experiences, and they inspire a personal, relational element that goes beyond a single transaction because new customers want to have the positive customer experience they read about. Use this desire to your advantage by putting your best testimonial stories where they'll have the most impact.

"THANK YOU" MARKETING

Last but not least, gratitude and "Thank You" marketing is the best way to maintain lasting relationships and encourage collector mentality in your customers. "Thank You" marketing is a form of communication that should be done with the upmost intentionality.

An audience is earned. Collectors are earned. Partnerships are earned. "Thank You" marketing is an intentional effort not to take these very important people for granted.

How can you infuse "Thank You" marketing into your post-purchase communications? Businesses that forget about their one-time-purchase customers may wonder how to get them to come back again. Forgetting to follow up with new and existing customers is like leaving money on the table, but doing so also leaves relationships and opportunities on the table too.

Handwritten notes, emails, and other electronic messages can be sent to thank someone, wish him or her well with the

purchase, and express that the business will be available for future needs. This type of additional contact goes a long way to increase the positive emotional connection with a business and individual seller.

How can you show your customers your gratitude for their business and support? Is there an annual opportunity to infuse a customer appreciation twist into your communications? When can you schedule a collectors only "Thank You" event at your studio? Are there loyal customers and audience key holders who deserve some credit for your business revenue last year?

Any method of engaging with your customers to show your appreciation increases your rapport and relationship with them.

CLASSIC, NON-TECHNICAL CUSTOMER SERVICE

In every situation requiring human interaction, emotions must be anticipated and expectations managed. No matter how savvy you become in the electronic components of business and communications, the ultimate sign of a good creative business is customer rapport and soft skills.

Customer service is what creates that emotional connection or disconnection that keeps people coming back or running away. Strong emotion in one direction or another can either elevate or damage relationships. Positive emotional responses make selling much easier.

In business, one surefire way to measure results is through your sales numbers. But the real fun comes when the human element is present. People want to support you.

visualize

"Eighty percent
of success is
showing up."

— Woody Allen

USING THE INTERNET TO INCREASE SALES AND VISIBILITY

We were nearing the end of a full day of talks and panels. Conference attendees were excited by the possibility and new information presented earlier in the day, but energy was waning. By 4 p.m., most were ready to go home.

I sat in the auditorium as it filled, and when Kyle took the stage like a pro, I felt the crowd's energy perk back up. Everyone's full attention was on his presentation.

To introduce himself, Kyle played a short digital film that matched quick video clips and images with his voiceover narration. It was the low-budget type of video production that

195

To learn more about Kyle T. Webster, visit his website kyletwebster.com and kylebrush.com. You can also find him on social media at: KyleTWebster.tumblr.com

Facebook.com/pages/ Kyle-T-Webster Illustration/42898441272

Twitter.com/KyleTWebster

Society6.com/ KyleTWebster

invites you into someone's unedited life. The audience was hooked.

In his thirty-minute presentation, Kyle T. Webster took us on his freelance journey from illustrating and posting "daily figure" sketches to a blog, to being hired as an on-assignment artist, creating illustrations for the likes of *The New Yorker*, *Time*, *WIRED*, and *The Washington Post*. Many of the leading publications in North America and abroad have at some point featured Kyle's illustrations.

To that end, Kyle has redefined himself as a "first order creative," taking on the philosophy of fellow illustrator John Hendrix, who ranks "first order creatives"—as opposed to second or third order creatives—as those who direct and author his or her own creative content in his or her own style to create opportunity.

The "first order creative" philosophy directs Kyle's business and project interests, and it diversifies his creative offerings. I had the opportunity to interview Kyle about what it means to be a first order creative:

Heather: Kyle, let's dive in at the tipping point of your career, around the time you discovered John Hendrix's "first order creative" philosophy. What impact did it have on you?

Kyle: John gave a talk once where he described his own path toward becoming a first order creative—he now mostly writes and illustrates his own material. I read a transcript online a couple of years ago and realized that I was on the same path without consciously aiming for the title of a "first order creative."

At that moment, I made it my top priority to create new income streams from self-generated projects. I had already made a few apps and opened a print shop. I ramped up my marketing for those products,

added to them, began finally writing down and sketching all of my children's book ideas that had been piling up, and set out to make a premium set of Photoshop brushes.

Once I discovered how much more rewarding it was to be able to turn my own ideas into the things that sustained my business—without relying on client commissions and client ideas—there was no turning back.

Heather: You diversified your creative reach through smartphone app creation, but you say that coding and programming aren't your strengths. How did you breach this challenge to bring new products to the marketplace?

Kyle: Partnerships are wonderful things for creative people, provided they can find reliable professionals with good communication skills and similar work habits.

My app business partner lives in Ireland, but we work so well as a team that I can hardly believe we have never met. We use Skype and email to collaborate on our projects, and it all goes smoothly. If you can't complete a project on your own, there is certainly nothing wrong with finding somebody to help out, and the Internet makes that very easy.

Heather: In what other ways do collaboration and partnership play a role in your business?

Kyle: Art directors and creative directors expect me to be a good collaborator—this means I can take client direction and execute what is asked, but I am also confident enough to propose different solutions, wear different hats, and work around unforeseen obstacles.

197

Sometimes, being a good collaborator means not accepting a project at all. A client will respect your honesty if you tell them, up-front, that you are not the right person for a job, rather than trying to fake your way through it or trying to squeeze it into an already full schedule.

Heather: How important is it for artists to step outside of their studios to find opportunity through engaging with the world?

Kyle: Vitally so. Working in a vacuum rarely leads to the best possible results, except in short bursts.

Heather: How do you discriminate between "good" opportunities and those that aren't worth pursuing?

Kyle: Budget, my work schedule, and personal interest in a project are the three factors that determine whether or not I accept a job. Two out of these three must be right, or experience has taught me that it is probably best to pass.

If I am not creatively excited about the work, but the budget is good, and I have the time to accept the project, then I am happy.

If the budget is not great, but I am creatively excited about the project, and I have time, then I am happy.

If the budget is great, along with my personal interest, but I'm already swamped, I regrettably have to pass. I have learned that saying, "No," more often leads to [other opportunities for] career growth, though it is always a hard thing for a freelancer to do.

Heather: What advice would you give other illustrators, graphic designers, and artists who want to create full-time?

Kyle: Whenever you are not working on something for a client, do not sit and wait for the next project to arrive. In between marketing and other "business" activities, make time just to play, and out of that experimentation, your best creative work will emerge.

Diversification is one way of putting your skills and strengths to work. A balance of online sales from your website and from a handful of other websites, compounded with the traditional power of in-person sales will set you up for a variety of income streams and, therefore, greater predictability in sales.

In the first part of this chapter, we will focus on getting you set up for sales online. Then, in the second part, we'll discuss a few methods for increasing traffic to your website that can accompany your marketing plans.

USING YOUR SKILLS TO INCREASE CASH FLOW ONLINE

Our lead-in story of how Kyle T. Webster turned his talent into multiple streams of income is an illustration (pun intended) of letting your creativity work for you in a digital world. Kyle has identified markets for his multi-passionate creative capabilities and skills:

- *He sells original illustrations to individual consumers and established publications.*
- *He sells illustrator tools that fill a marketplace need for graphic artists and illustrators.*
- *He makes a few apps that add value to smartphone users.*
- *He speaks at conferences.*

199

> If you are a multi-lingual artist, take advantage of the low hanging fruit of attracting international buyers through a multi-lingual website.

- *He probably has a few more tricks up his sleeve too.*

The point is: If you are a multi-passionate creative solopreneur, you can turn your talent and skill into opportunity. When your offerings add value to others in any large or small way, they can become a revenue stream for you.

The Internet is the most optimal place to position and sell your offerings because the world is already playing there. The Internet is also the single largest marketplace of prospective fans, buyers, and collectors.

Start by introducing one offering to the market at a time. Use the tools and practices found within this book to get set up; then repeat the process with your next offering when you are ready to expand.

The common thread in everything you do, make, share, and sell is you—your style. In many cases, housing all of your value-adding skills and talents under one website keeps things simple. Once you branch out to find a variety of audiences that are diverse enough to warrant targeted information, it may be best to consider using a different website for each offering-to-audience focus.

ADDING PASSIVE INCOME TO YOUR FINANCIAL FUTURE

Any creative business can benefit from passive income—residual income opportunities require energy to set up, but then bring in extra revenue once they are in place. Passive income is not to be confused with a side job that adds to your workload.

Passive income is ideal for creatives and artists because it sets up cash flow streams that fuel and support your passions. For example, if you make a series of digital prints that sell very well within certain niche markets, you can position those prints where consumers will be able to find and

purchase them directly from the Internet. Meanwhile, you, uninterrupted in your creative work, can go about creating while your digital prints earn money. The prints may take time to make and market, but once they are made, they act as a recurring revenue generator so long as they are attractive to the market.

If you want to retire some day and continue earning money without necessarily being obligated to create, passive income opportunities may be worth looking into.

To help you entertain the idea of adding residual earned income from your creativity into your overall revenue, here are some passive income opportunities for you to consider:

- *Sell your extra photos on stock photography websites that allow you to upload and license your photos to everyday buyers for a percentage of the sales price. Two sites to start with are ShutterStock.com and iStockPhoto.com.*

- *Make and sell eBooks and Digital Downloads, both of which work well for creatives who teach and use an info-sharing business model.*

- *Offer your skills and knowledge through recorded, online webinars that can be shared with paying customers over and over again.*

- *Sell prints and reproductions of your work.*

- *Sign up for affiliate programs and sell promoted products (see Chapter 4.)*

Overall, passive income extends your creative capacity by adding value into the marketplace under your signature. If your creative work is labor intensive, passive income that adds to your revenue plans sustains your most precious instrument: you.

CURATING AN ECOMMERCE EXPERIENCE

Monetizing a website can be as simple or robust as you need it to be for your business. Today's eCommerce experience let's you sell physical products and goods that are mailed to customers, digital downloads that can literally get you paid while you sleep, and virtual experiences that connect you with your audience.

Because an eCommerce experience takes place online, sellers and buyers can connect globally, giving even the smallest businesses worldwide sales distribution. Think of eCommerce as a virtual store with the same capabilities as a brick and mortar one, but without the physical space—and without the space-related overhead.

An eCommerce store can invite customers to take advantage of discount promotions, educate customers on products, manage inventory, accept payments, print shipping labels, send notification messages to customers, and do a nearly infinite number of other things. With the assistance of excellent product photography and engaging sales copy, selling online has become a popular method for getting paid.

Many website platforms with online sales capabilities can connect to third party payment processors like PayPal. WordPress users can use the free WooCommerce plug-in to sell directly from their websites with the robust customization offered through the plug-in. Squarespace.com users can set up an online shop directly from their websites too. There are also options such as Storify.com that are primarily focused on creating an eCommerce and inventory experience.

When setting up an eCommerce store, remember to test it several times from a customer's perspective before launching it live. In addition to promoting your offerings from your website, you can also promote positive customer experiences by asking for feedback and reviews on purchases. Adding social proof of how people interact with and enjoy what you make can increase interest and sales.

Performing artists and storytellers can take advantage of the opportunity to connect with their audiences through virtual ticket selling vendors like StageIt.com and ConcertWindow.com. These eCommerce platforms sell virtual concerts and "time" for performers to connect with fans globally, from the comfort of their living room. A digital concert experience, while broad in reach, creates an intimate "behind the scenes" with the performers, and reduces touring costs.

EXPANDING SALES OPPORTUNITIES TO OTHER PLATFORMS

Whether you started your eCommerce sales on websites like Etsy.com and Ebay.com or you are considering expanding to such platforms, you should be aware that your website is the only eCommerce platform you have complete control over. This control includes branding, messaging, promotion, how your customers navigate the site and their checkout process.

The most convincing fact, however, is that by investing in someone else's platform for your business and sales, you are entirely dependent on that platform's existence for your business. If Etsy is your only connection to your buyers, and it for some reason decides to close up shop, you're out of luck. In essence, you don't want to plant your fruit tree in your neighbor's yard because when your neighbor moves out, your fruit tree will be in yet another person's domain.

That is not to say that expansion into online sales platforms outside of your website isn't worthwhile. Hundreds of thousands of buyers are shopping for specific items and for various reasons on major multi-vendor websites like eBay, Amazon, and Etsy. The benefit to the seller and the buyer in this case is that the platform already exists and is ready to use.

If your product and artwork fit within an eCommerce model, meaning that what you make is easily shippable or downloadable, it would behoove you to have a presence in marketplaces that are already designed for sales because the buyers are there. However, cross-promotion from those platforms to your own website is a must.

How does one promote his or her own website while selling from another? One option for directing buyers to your website after they have purchased your goods from another platform is to use email marketing communications to thank them for their purchase and invite them to take advantage of an incentive offer exclusive to your website.

By thanking them for their purchase and directing them to your website for future purchases, you're giving them an opportunity to engage with your brand and purchase directly from you next time. When people purchase directly from you, the middleman is eliminated, thereby helping you recoup more of the sale.

Another method for directing sales of your goods from one selling platform to your website is to include opportunities to engage with your website and brand inside your physical mail packaging. A friendly message that leads new customers to your website for their future purchases is helpful. Infusing your branding in your packaging and offering an incentive on next-time purchases from your website tells buyers that they get even more when they choose to buy your offerings directly from you.

This direct sales goal can be further supported by "website-only" promotions from your site that cannot be found anywhere else. If people can buy your book on Amazon.com, but they can only buy your signed book from your website, they may choose to purchase directly from you in order to get something more.

Whether you are selling physical products or downloads, commissioned images or stage time, for the widest visibility in eCommerce sales, use a multi-platform strategy that connects you with new and existing fans.

STAYING HUMAN IN THE WORLD OF ONLINE SALES

The one thing an online sales experience lacks is the human element of a seller to buyer transaction. However, the human element can be infused into the buyer's purchase experience with the help of thoughtful language and detail embedded within each touchpoint the buyer has with the product.

A buyer's shopping, checkout, shipping, and receiving experiences are all opportunities for the seller to go the extra step to make the buyer's experience positive, personable, and memorable.

Couple that rewarding experience with the power of social media to share your buyers' experiences, connect with them, and thank them publicly for their purchase, and you have a plethora of opportunities to infuse creative, human communications into digital sales.

Leverage the tools at your disposal strategically to connect with your audience and leave them with a positive and memorable experience.

SEO LIGHT: CREATING OPPORTUNITIES TO BE FOUND ONLINE

With search engines learning so much about us that they remember our birthdays when our best friends don't, it's no coincidence that search engine results appear to be tailored to our interests.

Google, Bing, and Yahoo search engines strive to be as relevant as possible in the search results they provide.

Think about your own search behavior. When you search for anything on the Internet, you're likely to pay attention only to the website results on the first page, and you may not even scroll below the first three listings. Search engine optimization (SEO) is what many employ to take a webpage from the twentieth listing in the search results to the first. SEO is among the best ways to reach out to increase your chances of being found online.

SEO is one way of helping prospective customers find your business and your creative offerings when they are searching for specific terms—or "keywords" and "key phrases."

> For WordPress users, there's a free plug-in called Yoast WordPress SEO that can be installed with a few button clicks to add to your website's SEO potential.

When searching for yourself on your own computer, you'll almost always show up on the first page of Google search results. Why is this? Well, it goes back to Google knowing when your birthday is. Search engines have a memory of what you've searched for in the past, and they can use that digital knowledge to determine where you are going next. If you search your own name and website URL in Google to see how well you rank, you're bound to rank high because the topic is relevant to you.

To conduct a true search on yourself, start by searching for your name, your business name, and a combination of your name and your craft in a search on someone else's computer. You can also try a few searches on a browser you rarely use. Internet Explorer users may want to see what a search in Firefox or Safari yields. You will also want to make sure you are not signed in to any of your accounts while conducting searches.

Next, check out these online resources to get a more in-depth view of your SEO ranking and how to increase it to show up for the terms people are using to find you:

- *PageRankChecker.com*
- *SEOSiteCheckUp.com*

The Opposite of Hide & Seek: Making Yourself Findable in Search Serendipity

One tactic for increasing your odds of being found by others online is to get your website URL listed on other websites, thereby directing website traffic from other sites to yours.

To accomplish this goal, list your website on "Local Artists" registries associated with your town or city, and add your website to registries within your genre and medium. Another method for linking your website to other websites is to connect with bloggers for feature interviews. Bloggers who choose to showcase your story and craft can include your website in their interviews. What other opportunities can you think of for getting your website listed on other websites?

Getting people to look your way in a search listing is not enough. They have to keep coming back to your site and choose to invest with their time and/or with their dollars. Repeat site viewership is another vote of confidence in the direction of blogging because blogging creates new, fresh content for your website viewers.

Using Google+ to Increase Visibility

Google+ is more than just another social media platform. Perhaps you've noticed the Google+ notifications in your own Google searches—some search results are authored or shared by Google+ users. So if you decide Google+ is worthwhile for promoting content, your authored posts and shares will only increase your visibility in a Google search.

Saving Time by Outsourcing SEO

Busy artists who lack the time, confidence, or SEO expertise can achieve their goals by outsourcing SEO-related tasks to someone with SEO skills. One of the easiest ways to do this is by hiring a freelance SEO expert. Look to freelance websites such as Elance.com, Guru.com, and oDesk.com for reliable freelancer and SEO experts who won't cost you a fortune. In fact, freelancers who use sites like fiverr.com to market their services will offer to do SEO and many other tasks starting at $5. There's no need to pay an arm and a leg if your SEO needs are incremental and can be organized based on priority.

visualize

"Worry not that no one knows of you; seek to be worth knowing."

— Confucius

CULTIVATING COMMUNITY AND THOUGHT LEADERSHIP

On a rainy Tuesday afternoon, I ascend the echoing stairwell of a repurposed warehouse in Brooklyn's transitional Bedford neighborhood, a historical neighborhood quickly becoming repopulated with young, unmarried, artsy twenty and thirty-somethings using the energy of nearby Manhattan as the stimulant for their creative pursuits.

I am here to meet Greg Lindquist, an artist who moved to the Clinton-Hill neighborhood of Brooklyn in 2004 to attend Pratt Institute for graduate school before moving to Bedford.

Greg meets me at the door and welcomes me into his shared studio space where a freshly finished painting hangs to dry on the wall. We sit together at a small table where over the

To learn more about artist Greg Lindquist, visit GregLindquist.com and Wikipedia.org/wiki/Greg_Lindquist. And find him on social media:

Twitter.com/greglindquist

next hour we establish rapport and swap a few stories over the two Bordeaux-style canelés I picked up at the Balthazar Bakery on Spring Street a half-hour earlier.

Naturally, "Who do you know?" finds its way into the conversation. This is common in almost any point-of-origin discussion where two or more people have worked in a particular field or location over a period of time. It's an important part of getting to know someone because it establishes a network of context linking connections and degrees of separation. "Who do you know?" suggests where you have been and where you are going. It also implies "who knows you."

Having lived in Brooklyn for ten years, as well as having visited places like Tbilisi, Georgia to explore the vast landscape and collaborate with other artists, Greg expands his artwork and network around his areas of interest: changing contemporary landscapes, environmental issues, art, and art history.

Within his areas of interest, Greg has cultivated community in the arts as an active community member. He is an artist who works steadily to create bodies of work and secure showings and opportunities for his career, but he also contributes to the greater art discussions as a writer, lecturer, and participator. Like many professional artists, Greg makes an intentional effort of participating in the art conversations that take place outside of his studio. This act of intentionality adds to the art community and establishes Greg as a contributing player.

No matter how deeply entrenched one becomes in his or her own creative work, community-oriented artists often receive more attention for their work because it expands beyond their studio. Along with the inherent benefits of having community, artists also can expand their careers and grow artistically by appreciating others' works.

For general advice on career advancement, Greg offers the following anecdote and advice:

> Recently, a Pratt undergrad wrote me asking for advice on how to advance his career aggressively. He'd been painting for four years in a college setting and his work was of a strong student quality. I thought it was a funny question because he voraciously wanted this mythical career that shouldn't be a priority that early out of college.
>
> You have to have real world experiences and focus on the work itself as much as on the relationships. This means being at once critical and permissive in how it could develop. There are many artists who work tirelessly on creating a professional network, but, ultimately, the work is fairly undeveloped and weak. Getting someone to look at your work doesn't mean he or she will like it.
>
> I think it's really important to read as much as possible: literature, philosophy, art criticism, the newspaper. Those are the fuels as much as active making that will propel an engaged and developing practice. You cannot advance your work without the support of a community and an audience.

No plan to grow one's career can ignore human emotions and relationships. If it does, the chances are that it will not quite work out. People often reach a level of success because of the quality of their work, their work ethic, the people they know, and the relationships they keep.

A RELATIONSHIP MANAGEMENT MUST-HAVE

As mentioned in Chapters 3 and 9, a contact (or customer) relationship management system, known as a "CRM," is a valuable tool for managing relationships and keeping track of opportunities. Paired with good note-taking skills and a

A few digital contact management tools worth considering are:

- Streak.com

- OnePageCRM.com

- Nimble.com

- Zoho.com/crm

system that syncs with your calendar, a CRM can help you maintain a higher level of professionalism as opportunities evolve.

For easy-to-access, confidential notes, using a digital tool that stays on your computer or goes with you on your phone makes relationship management easier.

Depending on how important keeping up with relationships, sales, and opportunities is to you, and depending on your budget, you may want to start with a free or low-cost CRM system to test how it suits your needs; then, switch to another resource if you aren't satisfied. I recommend using a CRM tool that integrates with your calendar so you can schedule follow-ups and know when your last communication with a contact took place. This is especially helpful when you need to keep up with buyers, press contacts, and grant awarders—relationships that require more detail than a few loose notes scribbled on paper.

TAKING YOUR ART BEYOND YOUR MEDIUM

Historically, art has shaped the way people receive information, understand themselves, and experience the world around them. Wherever there is a movement, a revolution, or a simple message worth sharing, there is art. Art is a tool for cultivating community and thought leadership, whether it be through physical craft, written and spoken word, music and performance, or any other means of communicating ideas through the senses.

Artists have the ability to take their art beyond their medium, carrying with them messages for others to experience and interpret. The word "artist" is limitless, creating an abundance of opportunity to engage with audiences and communicate meaning. To communicate meaning, artists are only as restricted as they think they are.

THOUGHT LEADERSHIP IN COMMUNITY

For urban designer, Matt Tomasulo, design is the go-to language for promoting dialogue around community-related topics. To move his design ideas from concept board to public arena, Matt started with a student project in design school. He found a map style that effectively communicated the likeness of two cities, and screen printed them on two T-shirts to show comparison and generate conversation.

This experimental design project turned into something much more. Matt took his map T-shirt idea to the public under what would later become the brand, City Fabric®. Through a successfully promoted and funded Kickstarter campaign, he amassed a following of supporters who turned into loyal customers and PR opportunities. People liked the idea of engaging with others and talking about their cities. Wearing the T-shirt became a conversation starter that was well timed as the "local" movement was already underway during the recession.

To maintain the momentum created by his T-shirts, Matt set out again to redefine the way downtown dwellers engage with their cities. His overnight guerilla signage experiment, called "Walk Raleigh," encouraged residents of downtown Raleigh, North Carolina, to choose to walk to nearby places rather than drive. This experiment turned into his next big project. *Walk Your City* put Matt further on the urban planning map with the help of international press and, subsequently, another successful Kickstarter campaign funded by his growing audience of supporters.

For Matt, the mission of city-focused projects stretches beyond T-shirts, canvases, and signage. His mission encompasses a bigger conversation about making cities more comfortable for people to live in. As a result of his high-level mission and project success, Matt has earned a seat at the table of bigger conversations around design thinking and urban planning in cities around the globe.

To learn more about Matt Tomasulo's projects, visit WalkYourCity.org and CityFabric.net. And, join the conversation on social media:

Twitter.com/WalkYourCity

Twitter.com/CityFabric

Facebook.com/WalkYourCity

Facebook.com/CityFabric



Walk Your City has spread to over one hundred cities and is largely initiated by citizens who are aware of the project and want to make an impact where they live. The prototype project, Walk Raleigh, was a part of the thirteenth annual Venice Biennale. Matt's work has been featured on the *BBC News*, *The Atlantic*, *Bloomberg*, *NPR*, and many other news and media outlets. His curiosity fuels his passion, and his passion creates opportunity.

ASK NOT WHAT THE COMMUNITY CAN DO FOR YOU

A major component of entrepreneurship is providing a solution to a problem and satisfying a need. Artists and creative entrepreneurs are natural problem solvers; they are influencers who can help people connect with the past and imagine the future. Much like Matt Tomasulo who found a solution in encouraging walking over driving, when you train your mind to identify areas that are lacking—that you can creatively support—you are adding value and impacting the world.

Those gifted with the artistic vision to capture the world and tell their version of it can use their skills and talents to support causes in a unique way. Engaging with your community—be it your geographic community, area of personal and professional interest, or another—can be both rewarding and can position you as a leader in many ways.

By stepping out of your comfort zone to observe and learn from your surroundings, you'll bring fresh energy into your craft. When you add value to the larger community, you may also start to get noticed as a key player, contributor, and leader.

Think of the people who have had the biggest impact in your artistic field—think about their level of engagement outside of their studios and their contributions to their fields. Those who are named in the history books and in modern publications are the ones who take risk and deviate outside

of what is average and normal. They are notable because they impact the community as a whole.

If you want to elevate your career and professional reputation, think first of what you can do for the community before asking what the community can do for you.

SHARING IS CARING; PASSION IS CONTAGIOUS

Those who work with enthusiasm exude an energy that is naturally contagious. And those who spend time building meaningful relationships in both their work and play can develop community influence that elevates their efforts.

Share your passion, whatever it may be. Doing so will open doors that you cannot plan for and will expand your creative work by way of community. If you are committed to sharing your passion authentically and developing a community of interest around shared passions, you will find that when you are ready for greater things to happen, your community is there to support you.

"Not everything that counts can be counted, and not everything that can be counted counts."

— Albert Einstein

12

DOCUMENTING YOUR SUCCESS

When photographer and graphic design professor Shannon Johnstone was presented with her second opportunity to use sabbatical time off for project and portfolio development, she took the opportunity and approached it differently than she had before.

Much like her first sabbatical, Shannon was required to create a plan of action to outline her plans and intentions during the sabbatical. This time, to make sure she had the ball rolling before she stopped teaching, Shannon began working on her sabbatical project nearly eight months prior to taking leave.

Shannon's project, a photographic storytelling of shelter dogs that, without adopters, are landfill-bound, has taken on a life of its own. Her project is called *Landfill Dogs* and has been featured in news media outlets including *World News with Diane Sawyer,* Mashable.com, *The Examiner,* LaughingSquid.com, Buzzfeed. com, and *The Huffington Post.*

To learn more about Shannon Johnstone and *Landfill Dogs*, visit ShannonJohnstone.com, and find her on social media at Facebook.com/LandfillDogs and Twitter.com/LandfillDogs

Had she not approached the project by documenting the little successes from the beginning, Shannon wouldn't have been prepared for the magnitude of press coverage she received.

The project's goal is to find homes for shelter dogs. This goal, defined before the project began, creates the ongoing definition of project "success" as Shannon sees it. Each week, she photographs shelter dogs playing and running freely atop a nearby landfill park—a park that sadly becomes the resting place for many of the animals that are not adopted. As an advocate for shelter dogs finding homes, Shannon uses her creative skill and passion as a catalyst to give voice to the cause through the storytelling power of her camera.

She tracks how successful she is in connecting dogs with adopters using several detailed spreadsheets. Shannon tracks the lives of the dogs using variables such as gender, age, adoption status, tracking ID number, etc.

Some dogs find homes after a few days; others find homes after several weeks, and some have yet to find homes. Her tracking system gives her flexibility in accounting for things such as adopted dogs being returned, dogs getting sick, and a number of other unforeseen details. Shannon has become more than an advocate and photographer. She has become the keeper of the life events and histories of the shelter dogs.

These documented details and tracked data points aren't necessarily important for the fine art aspect of her photography. But, as it turns out, they are very important for sharing numbers and details with those who can amplify the project's message. Whenever someone from the press wants to share a photo or a story about a specific dog, Shannon can reference facts and other story-building points that add impact, thereby increasing adoption rates.

Shannon's documentation process adds validity and credibility to her work. Ultimately, this level of documentation is what keeps Shannon's cause in the limelight, connecting

adopters with dogs in need of homes, and creating continuous project successes.

DEFINING SUCCESS BY STARTING WITH THE END IN MIND

Defining success for yourself is a must. Whether pursuing a single project or a creatively entrepreneurial life, the results you desire at the end of the day are what will help you determine and measure your own standards for success. That said, small successes must be acknowledged because they are what build momentum and add up.

What does success mean to you? Is it a feeling or a sense of accomplishment? Is it qualitatively measured in the feedback you receive and the lives you touch with your artwork? Is it quantitatively measured by the number of awards, stats, Likes, and sales you get? Is it a combination of all of these?

Return to your Chapter 1 responses to see what matters most to you and what you are working toward. As you near the end of this book, your ideas of what you are after may have changed, or they may be the same. Go back and see for yourself.

ADDING DEDICATED REFLECTION TO YOUR ROUTINE

When you feel the world is moving too quickly for you to keep up with it all, add quality to your life by dedicating time for reflection into your routine. Journaling and meditating as you and your work evolve will keep you present. Physical activity will get you out of your mind and into your body.

Add dedicated time for reflection into your routine often. Reflect on where you have been and daydream about where you want to be to maintain balance and equilibrium within yourself because only you have the artistic vision to capture the world and tell your version of it.

A FINAL NOTE

If you read this book and find that you have more questions than you started out with, great. You are processing and learning.

In reading this book and completing the exercises, it is my hope that you now have:

- ☐ *more awareness of your own strengths and weaknesses.*
- ☐ *systems that make the "business-side" more manageable.*
- ☐ *measurable targets to aim for in your art business revenue.*
- ☐ *the strength to recognize when it's time to bring in support.*
- ☐ *an understanding of how to position your creative offerings for the markets that will support your livelihood and, therefore, support your creativity.*
- ☐ *unwavering principles that keep you grounded.*
- ☐ *a brand experience for your buyers that does the communicating for you.*
- ☐ *a new sense of how community can impact your life and business.*
- ☐ *routine that rejuvenates your spirit and energy.*
- ☐ *and the tools you need to Let Your Creativity Work for You.*

Now, what are your next steps? What are you going to implement? What offerings are you going to sell? Which key holders do you want to share your news with first? What do you plan to do in the next 90 days to move forward?

I challenge you to take action. Use your exercise responses as you craft your next steps and return to the sections that impact you whenever you need a refresher.

The two points I want to remind you of are:

1. *Long-term success requires that you be your best self. In doing so, you will share your passions with genuine enthusiasm and foster meaningful relationships.*
2. *To achieve the success you desire, it is critical that you cultivate an altruistic, entrepreneurial mentality, and be open to opportunity.*

I encourage you to keep the feedback loop open by joining me at HeatherAllenOnline.com. Tell me what impacted you, what you liked, and what you didn't. Tell me how you plan to turn your artwork into opportunity.

More importantly, let me know how I can help you. Contact me at info@HeatherAllenOnline.com. I'm never too busy to make time for my readers, and to say thank you for reading my book. Take advantage of a complimentary consultation with me to create a marketing strategy tailored to your art business needs. Don't hesitate to reach out—I wrote this book for artists like you.

I wish you much success in your journey of letting your creativity work for you!

Heather Allen

REFERENCE NOTES

Allen, Heather. "Artists Draw Fans from Facebook." *The News & Observer*. Raleigh, NC. March 4, 2014.

Bhandari, Heather Darcy and Melber, Jonathan. *ART/WORK: Everything You Need to Know (and Do) As You Pursue Your Art Career*. New York, NY: Free Press, 2009.

Briggs-Myers, Isabel and Myers, Peter B. *Gifts Differing: Understanding Personality Types*. Mountain View, CA: CPP, 1980.

Collins, Jim and Porras, Jerry. *Built to Last: Successful Habits of Visionary Companies*. New York, NY: HarperCollins, 1994.

Crawford, Tad. *Legal Guide for the Visual Artist*. 5th ed. New York, NY: Allworth Press, 2010.

Chopra, Deepak. *The Seven Spiritual Laws of Success: A Practical Guide to the Fulfillment of Your Dreams*. San Rafael, CA: Amber-Allen Publishing, 1994.

Ferris, Timothy. *The 4-Hour Work Week*. New York, NY: Random House, 2009.

Godin, Seth. *Linchpin: Are You Indispensible?* New York, NY: Penguin Group, 2011.

Godin, Seth. *Permission Marketing: Turning Strangers into Friends and Friends into Customers*. New York, NY: Simon & Schuster, 1999.

Kearney, Brandan and Wold, Peter. *NxLeveL Guide For Business Start-Ups: Helping Entrepreneurs Reach the Next Level of Success*. 5th ed. NxLeveL Education Association, 2009.

Leland, Caryn R. *Licensing Art & Design: A Professional's Guide to Licensing and Royalty Agreements*. New York, NY: Allworth Press, 1995.

Maslow, Abraham. "A Theory of Human Motivation." *Psychological Review*, 1943.

McCarthy, Carrie & LaPorte, Danielle. *Style Statement*. Boston, MA: Little, Brown and Company, 2008.

National Endowment for the Arts. *Artists in the Workforce 1990—2005*. Office of Research & Analysis by Deidre Gaquin, Washington, D.C., 2008. www.arts.gov.

Osterwalder, Alexander and Pigneur, Yves. *Business Model Generation: A Handbook for Visionaries, Game Changers, and Challengers*. Hoboken, NJ: John Wiley & Sons, 2010.

Pakroo, Peri H. *The Small Business Start-Up Kit: A Step-by-Step Legal Guide*. 6th ed. Berkeley, CA: Nolo, 2010.

Pink, Daniel. *To Sell Is Human: The Surprising Truth about Moving Others*. New York, NY: Penguin, 2012.

Rath, Tom. *Strengths Finder 2.0*. New York, NY: Gallup Press, 2007.

Rohrs, Jeffrey K. *Audience: Marketing in the Age of Subscribers, Fans and Followers*. Hoboken, NJ: John Wiley & Sons, 2014.

Sagmeister, Stefan. *The Power of Time Off*. TED Talk. Ted.com/talks/stefan_sagmeister_the_power_of_time_off

Sandberg, Sheryl. *Lean In: Women, Work, and the Will to Lead*. New York, NY: Alfred A. Knopf, 2013.

Tavern, Amy. *Trachodon*. 2010 (http://www.trachodon.org/issue-1-fall-2010.php)

Tharp, Twyla. *The Creative Habit: Learn It and Use It for Life.* New York, NY: Simon & Schuster, 2006.

YouTube: "The first video on YouTube, uploaded at 8:27 P.M. on Saturday April 23rd, 2005. The video was shot by Yakov Lapitsky at the San Diego Zoo."

Websites

Abcnews.go.com/WNT/video/ photographers-quest-save-dogs-shelters-21104443

Artdeadline.com

ArtwareEditions.com

Buzzfeed.com/adamdavis/ these-portraits-of-shelter-dogs-looking-for-homes-will-melt

Callforentry.com

Dealbook.nytimes.com/2012/04/09/ facebook-buys-instagram-for-1-billion/?_php=true&_ type=blogs&_r=0

Ibtimes.com/east-coast-earthquake-2011- twitter-faster-seismic-waves-304190

Theguardian.com/technology/2014/feb/04/ facebook-10-years-mark-zuckerberg

Volunteer Lawyers for the Arts (www.vlany.org)

ABOUT THE AUTHOR

Heather Allen is an author, speaker, and business consultant to visual artists. She helps self-employed artists earn more for their craft, and is the founder of Art Business Strategy + Access, a yearlong program designed to empower artists with business and digital marketing savvy to cultivate collectors worldwide.

An advocate for creative entrepreneurship, Heather has been a professional resource to artists since 2010. She has collaborated with a number of organizations to bring continuing education opportunities to creative professionals.

She received a dual-Masters in Global Innovation Management and Business Administration from NC State University and L'Institut d'Administration des Entreprises, Aix Graduate School of Management in Puyricard, France. She has undergraduate degrees in art, design and psychology. She studied art history and has been trained in a number of 2D & 3D arts.

Originally from St. Louis, Missouri, Heather lives in Raleigh, North Carolina, with her husband, Phillip.

To learn more, visit HeatherAllenOnline.com.

CPSIA information can be obtained at www.ICGtesting.com
Printed in the USA
LVOW09s0804020916

502736LV00069B/402/P